iPhone Photography for Everybody
Black & White Landscape Techniques

Create
Pro Quality
Images

Gary Wagner

AMHERST MEDIA, INC. ■ BUFFALO, NY

The author acknowledges, with gratitude, his wife Susan for her encouragement, discerning comments, and assistance with this book.

Published by:
Amherst Media, Inc.
PO BOX 538
Buffalo, NY 14213
www.AmherstMedia.com

Published by:
Amherst Media, Inc.
PO BOX 538
Buffalo, NY 14213
www.AmherstMedia.com

Publisher: Craig Alesse
Associate Publisher: Katie Kiss
Senior Editor/Production Manager: Barbara A. Lynch-Johnt
Senior Contributing Editor: Michelle Perkins
Editor: Beth Alesse
Acquisitions Editor: Harvey Goldstein
Editorial Assistance from: Carey A. Miller, Roy Bakos, Jen Sexton-Riley, Rebecca Rudell
Business Manager: Sarah Loder
Marketing Associate: Tonya Flickinger

ISBN-13: 978-1-68203-428-6
Library of Congress Control Number: 2019957389
Printed in the United States of America
10 9 8 7 6 5 4 3 2 1

AUTHOR YOUR iPHONE BOOK WITH AMHERST MEDIA

Are you an accomplished iPhone photographer? Publish your print book with Amherst Media and share your images worldwide. Our experienced team makes it easy and rewarding for each book sold and at no cost to you. Email submissions: craigalesse@gmail.com.

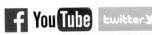

www.facebook.com/AmherstMediaInc
www.youtube.com/AmherstMedia
www.twitter.com/AmherstMedia
www.instagram.com/amherstmediaphotobooks

Contents

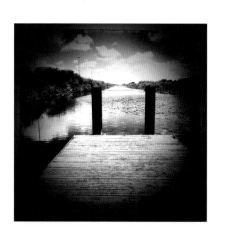

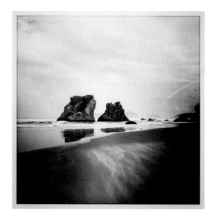

About the Author

Gary Wagner's love of the photographic image and craft began when he became the photographer for his high school newspaper in Kokomo, IN. He continued his education at Indiana University in Bloomington and eventually moved to Santa Barbara, CA, to attend Brooks Institute of Photography. While at Brooks, Gary increased his artistic and theoretical knowledge of photography and the historical significance of the printed image. Earning a master's degree in photography from Brooks Institute, with the publication of his work on historical carbon printing, gave Gary a continued appreciation and passion for his artistic craft.

Gary's photos have been exhibited in many galleries and published in *Lenswork, Outdoor Photographer,* and *Digital Photographer UK* magazines, among others. He won numerous awards including Best of Show for two years at the Sacramento Fine Art Center, and his work was accepted into the California State Fair Fine Art Show. He also received awards eight years

annually in prestigious *Black & White* magazine.

Gary's recent achievement was the publication of his book, *Digital Black and White Landscape Photography: Fine Art Techniques from Camera to Print* by Amherst Media. He is also the author of three self-published books: *Sierra Nevada Mountains, Sierra Mountain Wilderness,* and *Redwood Coast: Sea and Land.*

Gary's professional career spans more than four decades and includes fine art, portrait, and commercial photography. His knowledge, expertise, and enthusiasm for the photographic image enabled him to successfully teach theory and technique at the college level and seminars in Europe on the English country landscape.

Fluent with all film formats, from 35mm to 8x10, Gary has embraced the digital image and the ever-changing environment of photography in the current technological age. Exploring photography using digital imagery offers myriad possibilities. Refining technique with the interplay of artistic expression fascinates and challenges Gary to continue his exploration of the photographic image and his study of the land and its natural elements and beauty.

For the past 30 years, Gary has made his home in northern California.

Introduction

The iPhone camera and phone is a technological marvel! The device offers the photographer unlimited potential to photograph and process images anywhere and at any time with utmost precision and convenience.

The first iPhones with cameras were introduced in 2007, with a 2MB camera and 128MB of memory. The iPhone 11, released in 2019, has a dual 12MP camera and 512GB of memory. I have been using the iPhone with the inception of model 5 in 2012. Having taken tens of thousands of images with this pocket camera has been a tremendously rewarding experience.

The images in this book were taken with five different iPhone cameras over the past seven years and were processed using a wide variety of software apps. During this time, the quality of the images produced with the iPhone has improved significantly, as have the variety and quality of the apps. Regardless of the improvements with the camera, any iPhone camera offers the opportunity to take excellent photos and convert them to beautiful black & white images that may rival those captured with any traditional camera.

This book is about black & white landscape photography using the iPhone camera. It is divided into seven chapters. The first chapter provides information on using the camera and processing images with a selection of iPhone apps. The following six chapters are devoted to landscape images from a variety of locations and scenery categories, including National Parks, Seascapes, Urban Life, Travel Iceland, Nature, and Trees. National Parks includes a selection of images made at national parks across the United States. National parks are one of my favorite locations to take landscape images due to the wide variety of scenery available in each location. The Seascape chapter includes images from the Pacific coast taken at a various times of day and in varied weather conditions. Urban Life features images taken in cities around the world and also includes scenes altered by man. The Travel Iceland chapter shows spectacular locations of this northern country in black & white,

including waterfalls and landscapes. The chapter on Nature includes intimate scenes of plants and natural settings and some close-up images. The final chapter is about Trees and where they are located in the landscape, as well as their relationship to light and atmospheric conditions.

All of the images included in this book were taken and processed using only the iPhone camera and dedicated software apps designed for it. Throughout the book, I describe what works in each scene and how the photo capture and processing were accomplished.

The potential for images to capture is only limited to the photographer's vision and imagination. Enjoy your camera, and have fun taking exciting black & white images of the landscape.

Seeing in Black & White

Black & white photography allows the photographer to create images outside of the normal visual reality. The world around us is seen in color, and color excites our visual emotions. Black & white photography does not have the advantage of color and, consequently, the photographer must look for other factors in the scene to create striking and memorable images. Light, contrast, line, shape, patterns, textures—are all attributes of outstanding black & white images. When the intention is to create a black & white photograph, you must begin with your vision. Seek out scenes that draw attention not due to color but to one of the attributes listed above. Look for light in the scene that creates dramatic shadows. The texture in rocks, sand, and rusted metal may also draw your visual attention. Explore the shape of objects that are unique or patterned. Do not seek out scenes dominated by muted tones or color.

"Seek out scenes that draw attention not due to color, but to one of the attributes listed above."

Great black & white images are created first by the vision of the photographer, the capture of the camera, and the processing actions used. Seldom are we able to make outstanding black & white images by processing alone. Look for the attributes of great black & white photos, capture the image with precision and solid technique, and process the image with software designed for successful black & white conversion. Following these guidelines will provide the groundwork for making outstanding black & white landscape images.

Capture & Processing

These four images show the iPhone photography process from a color scene to a finished black & white image.

The Color Image

I captured this photo *(below, left)* of a pier located in Trinidad, CA, at sunrise. The water was very calm on this summer morning, with a low tide, and the sky was a bold blue. Notice that I included foreground foliage at the bottom of the image, which forms a natural dark frame.

This second image *(below, right)* shows the camera, an iPhone XS, in a black case, with a color image of the pier on-screen.

When capturing images with your iPhone, hold the camera level if there is a horizon line in the scene. Also, it is important to hold the camera steady to get the clearest-possible photograph.

This photo was taken with the native capture app that comes with the camera and works great right out of the box. The other app used for many images in this book is ProCamera, which offers numerous additional features for customizing the photo-taking process.

Conversion to Black & White

The third photo *(following page, right)* is a screen capture of the pier image after it was converted to black & white. The Photoshop Express Pinhole filter was applied for conversion to black & white and darkened the edges of the image. The blue line under the image is a slider used to vary the intensity

". . . hold the camera steady to get the clearest-possible photo."

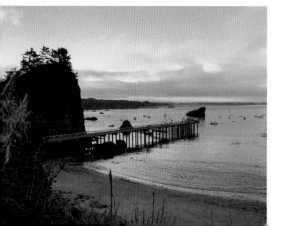

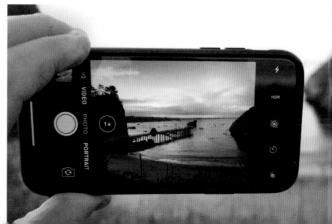

of the filter applied to the image. In this case, the slider was set to apply a minimum amount of the Pinhole effect. At the bottom of the screen shot there are other choices for black & white conversion that may be used. I also adjusted the brightness and contrast of the image using Photoshop Express.

The Final Image

Here *(below)* is the completed black & white photo of the pier. Several adjustments were made to produce the final black & white look. This rendition is one of the many possible ways to process an iPhone image. Creating an alternative photo rendition is always an option for the iPhone photographer.

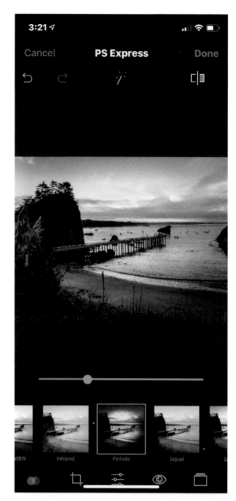

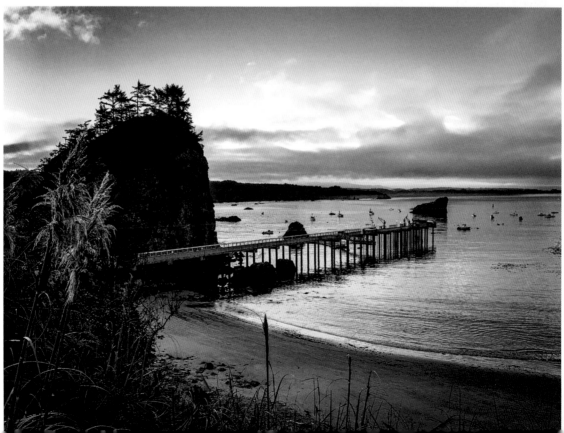

Capture & Processing Apps

The iPhone camera has hundreds of photo apps available for image adjustments and improvements. I have over 50 photo apps on my iPhone but tend to use 8 on a regular basis. I have created a directory, or folder, on my phone

labeled Photography, where I have all of my photo apps located on different pages. The ones I use the most often are on the first and second page, allowing for easy access.

The Native Apps. The iPhone has a built-in app called Camera, which can be used for taking images right out the box. I use it often for grabbing quick images of people or places. The iPhone also comes with the pre-installed app called Photos; it contains a number of albums for storing your images in an organized method. New apps appear in the App Store on a regular basis. Some are free, and others are available for a small fee. I am always on the lookout for those with improved options.

". . . use ProCamera to take photos and process your images."

ProCamera. You can use ProCamera to take photos and process your images. This is the app I most often use with my iPhone. Within this app, you can set the f-stop and shutter speed for your

left. **A directory on my iPhone provides easy access to all of my capture, processing, and photo-sharing apps.**

capture, create rapid-fire images, and use a self-timer. There are also file-saving options provided. In addition to the full array of photo-taking options, this program offers a complete list of image adjustments to alter and improve the look of your photos. Included are a variety of black & white preset filters that can be used for converting your color images to black & white.

TinType. The TinType app is used to create iPhone photos that resemble those that were printed on metal and produced in the 1860 to 1870s. These prints, made in black & white, were often soft in focus and contained processing flaws.

Using the app is simple, and a button is used for varying the softness of the image. However, the ability to make other changes to the image is very limited. Many times, after converting an image with this app, I open the image again in another app to further adjust the brightness and contrast.

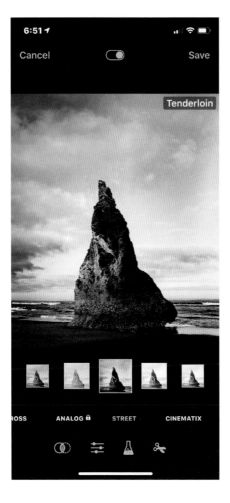

left. **This photo of a sea stack, taken in Bandon, OR, was processed using the Street/Tenderloin filter, giving excellent tones.**

right. **The TinType app allows photographers to create images reminiscent of a metal-print process popular in the 1860s and 1870s.**

Dramatic Black & White. This app is used to create a dark vignette at the edges of an image and lighten the

"This app is used to create a dark vignette at the edges of an image and lighten the center."

center and can give the appearance of a light shining on the photo. The vignette may be adjusted to the desired position. There are a variety of preset filters available, allowing custom lighting to be achieved. The app can be used at any time during image processing (i.e., before or after other apps are used).

Camera+. The Camera+ app offers a variety of filters for converting color images to black & white. I have used all of these filters successfully, as they offer many different tones and are easy to apply. Two of my favorite filters for converting images to black & white are Mono and Noir.

Photoshop Express. Photoshop Express is one of my favorite and most-used apps for converting color images to black & white. It has a complete toolbox of other adjustments for altering brightness, contrast, and a host of other items to improve the look of your image. Many of the tools included with this app are similar to the full-sized Photoshop program used by many professional photographers and graphic designers globally. This app has had many improvements in the past few

left. **The Dramatic Black & White app is handy for producing vignettes and drawing the viewer's eye to the center area of the image.**

years, making it readily usable. A large number of the photographs in this book were processed using Photoshop Express. I've found that using it produces some of the best-possible image alterations available.

left. I love the simplicity of Camera+ and the various processing options the app allows.

right. Photoshop Express is one of my favorite and most-used apps for converting color images to black & white.

Camera+ *(left)*. The Camera+ app is a fully functional app that can be used for all types of image adjustments. It has many black & white filters available to produce a variety of different looks. I have been using this app for several years and have found the Noir filter to be an excellent choice for black & white conversion. This app also contains a good variety of frames to use for borders on your images. I sometimes use border frames if I want the image to have a more finished look when I am using the image on social media.

left. Use the Noir filter in Camera+ to produce excellent black & white conversions.

PicPlayPost *(right)*. The PicPlayPost app is used for creating a collage of images in many different combinations and layouts. I have used this app occasionally and included a few images made with it to show how it can be used for telling a story and conveying a theme through a series of photographs.

In the screen shot below, you'll see three beach scenes, which I presented in a large size to show a more detailed view of the contents of each of the images.

Allow your vision for each photo to dictate the app and filter you will use to process your image.

"Allow your vision for each photo to dictate the app and filter you will use to process your image."

right. The PicPlayPost app is used for creating a collage of images in many different combinations and layouts.

CHAPTER TWO

National Parks

The national parks provide the most spectacular beauty and majestic landscape sights in the United States. First established in 1872 with the creation of Yellowstone National Park, today there are 61 national parks located from coast to coast. Black & white images have been captured by photographers since the park's inception, and during the last century was made famous by the work of photographer Ansel Adams.

This chapter includes a variety of images of parks and other scenic areas from across the country. These extraordinary and dramatic landscapes and unique views of specific regions provide the iPhone photographer with an introduction to seeing images and creating excellent black & white photographs.

below. **Half Dome, Yosemite National Park.**

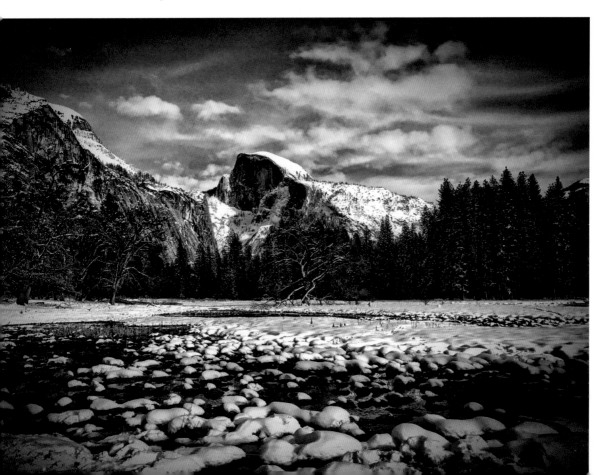

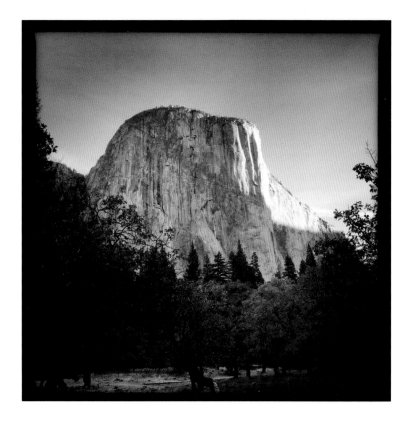

Half Dome

Half Dome, Yosemite National Park, is a classic location for black & white photography. Photographers and park visitors from around the world are attracted to the geologic and natural landscapes. The foreground of rocks and snow add drama to this image. The Dramatic Black & White app was used to convert the image from color to black & white, darken the sides, and enhance the clouds.

El Capitan

This image was made early in the morning as the sun came over the horizon and hit the face of this magnificent granite monolith. This type of lighting creates a three-dimensional look with shadows on the left and highlighting on the right. The dark foreground trees add to the wondrous look of the overall scene.

I used the Hipstamatic app for the iPhone and the Jane Lens and Claunch 72 Monochrome Film for black & white to process the image. The combination of lens and film filter allows for a warm-toned photo in a distinctive square format.

*"Crop images to a
square format to
make them unique."*

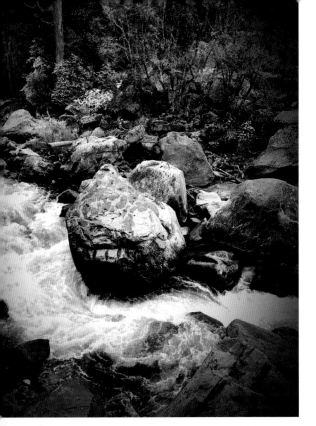

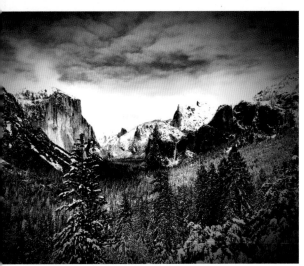

Merced River

The Merced River travels throughout Yosemite Valley and offers many excellent locations for capturing its power and beauty. At this location, the massive bolder seen in the middle of the image, and the water's path being forcibly changed, was an example of nature's adaptations.

This photo was captured using the phone in the vertical position. The image was processed with the Photoshop Express Pinhole filter.

Tunnel View

Tunnel View, Yosemite National Park, is another classic location for photography in the park. This overlook area is often crowded all year round with photographers with cameras and tripods, and others taking shots with their camera phones. Regardless of the camera and equipment used, an image of this subject is guaranteed to impress the viewer, whether sent by email or posted to social media.

This image was processed using Photoshop Express and the Black and White Pinhole filter set at 50%. I use this filter to darken the sides but not at full intensity, allowing the image a natural beauty.

top. Merced River, Yosemite National Park.

bottom. Tunnel View, Yosemite National Park.

Lower Yosemite Falls

Taking the trail to Lower Yosemite Falls allows for some excellent views of this ferocious water display. The trail is occasionally closed due to high water and overabundant spray from the falls. When the trail is open, however, it is a sight not to be missed.

This image was processed using the Photoshop Express app with the Pinhole filter. Using this filter at a minimum amount allowed for darkening of the edges of the photo while keeping the center, the waterfall, bright, making it the center of attention.

"Keep your phone covered until you are able to avoid water or mist on the lens."

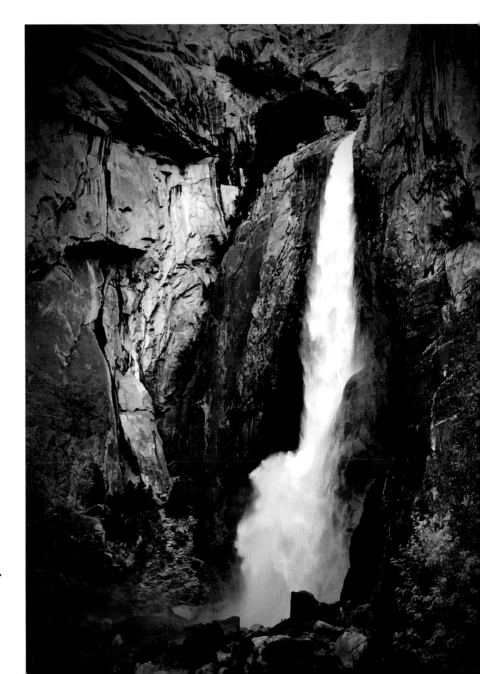

right. **Lower Yosemite Falls.**

View from Glacier Point

This photo of Half Dome was taken from Glacier Point at sunrise. The trees in the area were used to frame the scene, creating a more interesting border.

"Include framing around the borders of the image to make interesting photos."

below. Half Dome, Yosemite National Park.

Yosemite Park is the perfect location for black & white photography, as it has many strong graphic sights with powerful visual lines.

The photo was processed using Photoshop Express and the standard black & white filter. Increasing the shadow detail in processing will give more detail to the darker parts of the image.

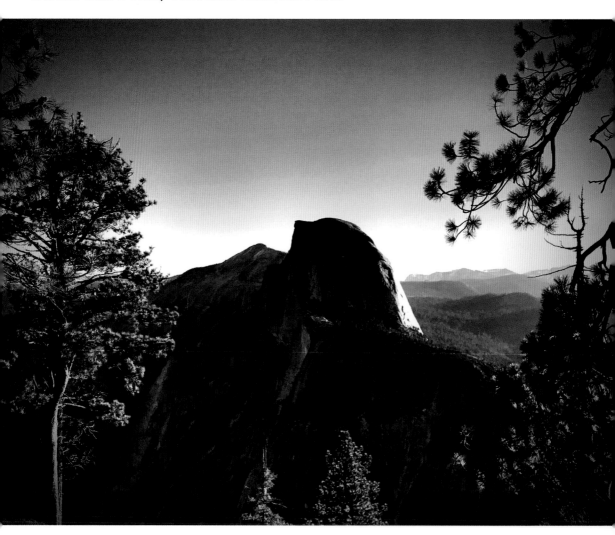

Vernal Falls

Vernal Falls from the Mist Trail is another spectacular hike in Yosemite. The journey to the top of the falls is considered strenuous, and during high-water times may become challenging due to the over-abundant water spray causing slippery conditions. There are many vantage points along the trail that provide spectacular photo opportunities for the falls and the flowing river. Many times, I have only walked halfway up the trail, as the water spray became excessive.

On this occasion, I was able to hike all the way up to Vernal Falls and capture this image. For the first photo *(top),* I used the Long Exposure mode to produce a soft and beautiful look to the water, while keeping the other parts of the image sharp and in focus.

When capturing this type of image and using the Long Exposure mode, hold your phone as steady as possible for the maximum focus quality.

The second image *(bottom)* was taken of Vernal Falls from the Mist Trail with the sun shining on the bottom of the falls and illuminating the water. I created a stop-action photo of the water coming over the falls. This image was processed with the Photoshop Express app and the Pinhole filter.

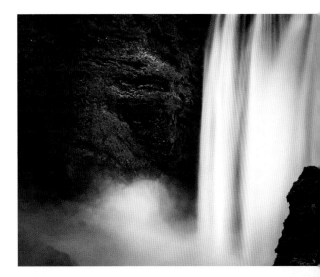

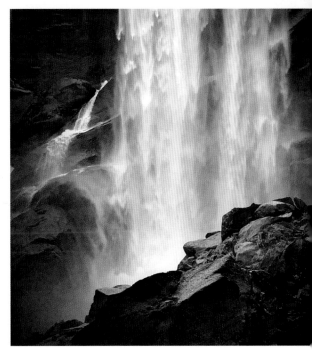

***top and bottom.* Vernal Falls, Yosemite National Park, as seen from the Mist Trail.**

The Merced's Mood

The Merced River may be fast and furious or soft and serene, depending on the season. Standing on the edge of the river and viewing reflections of the trees and mountains in the meandering on the water's surface, I took photos of the ever-changing river. The rocks in the foreground made a nice framing for the bottom of the image.

This image was processed using the Hipstamatic app and the Jane Lens, with the BlacKeys XF Film filter. This processing option created a soft, dream-like image that reflected the river's mood on the day this photo was taken.

El Capitan & the Merced River

This image of El Capitan was taken at sunrise to give the maximum amount of depth and contrast. Seeking to capture the mountain reflection in the river below and create a vertical image of

below. The Merced River.

following page, left. El Capitan and the Merced River.

following page, right. Death Valley sand dunes.

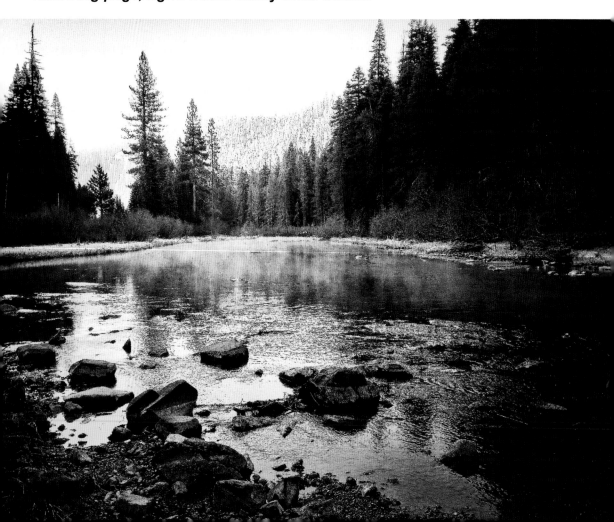

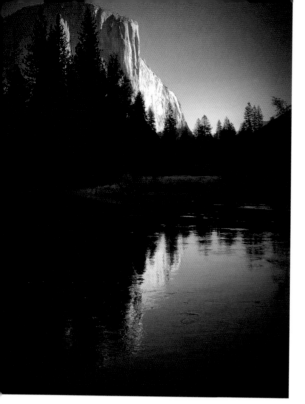

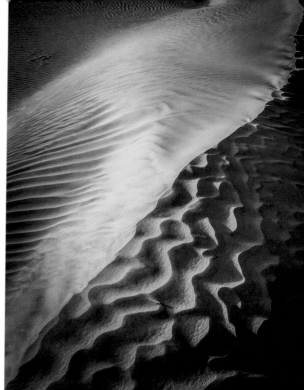

light and darkness, I was particularly pleased with the silhouette of the trees in the center.

Early-morning light is a photographer's friend. Getting out of a warm bed before dawn may be tough, but this image proves it is worth it.

The image was processed using Photoshop Express and the Pinhole filter to darken the edges of the image and further enhance the dramatic majesty of this mountain face.

Death Valley Sand Dunes

The sand dunes in Death Valley are a wondrous sight for photographers and visitors alike. The best time to take a photograph of them is at sunrise or sunset. The new light of the morning and the waning light of the evening crossing over the dunes gives texture and mystery to the undulating miles of sand. With cooler temperatures, winter is the best time to visit the park.

This photo was processed using Photoshop Express and the Pinhole Filter. The contrast was adjusted to make the dark areas of the photo darker.

"Center reflections in the photo to make them part of the composition."

> *"Look for unique lighting and include it in your photo for more interesting images."*

Death Valley

Sunrise in Death Valley is spectacular! In this photo, the mountains in the back are silhouetted by the sun. The dunes in the foreground show beautiful tones and textures from the light skimming across them.

In black & white photography, regardless of the type of camera you use, always look for the light on your subject before taking an image. Light is always a major factor in producing the best-quality photo.

This image was processed with the Camera+ app and the Mono filter. The highlights were adjusted to show the maximum detail in the brightest parts of the photo.

Badwater

This is Badwater Basin at sunset, with the evening glow of the sky reflected in the water.

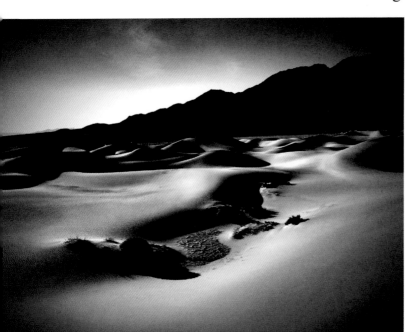

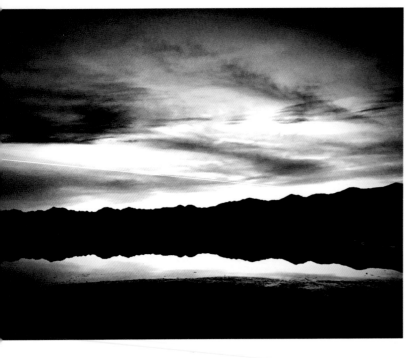

top. Death Valley.
bottom. Badwater Basin in Death Valley.

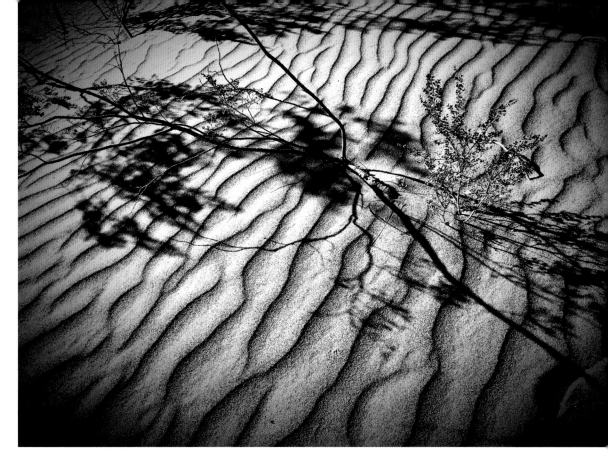

above. **Death Valley.**

Look for the best light and lines to great create black & white images. Another important part of this image are the clouds in the sky and their reflection in the water below. Always look for reflections to improve the drama of your photos.

This image was processed using Photoshop Express and the standard black & white filter.

Death Valley Patterns

The patterns and textures of the sand in the dunes always make for evocative photos. In this image, foliage on the sand gave shadows and design to the already distinctive pattern left by the weather.

To successfully take this type of image, strong cross lighting is a must, as it highlights the earthy texture. Though this image was made at sunrise, a similar look may be achieved at sunset.

This image was processed using the Photoshop Express app and the Pinhole filter to darken the edges of the image.

Dunes, Death Valley

The sand dunes of Death Valley are one of my many favorite landscapes to photograph. This image, taken early in the morning, captures the sun shining on the dunes, adding wonderful lines and texture to the photo.

The image was processed using Photoshop Express and the Pinhole filter to darken the edges of the photo and highlight the lines and texture in the center of the photo.

below. **The sand dunes in Death Valley.**

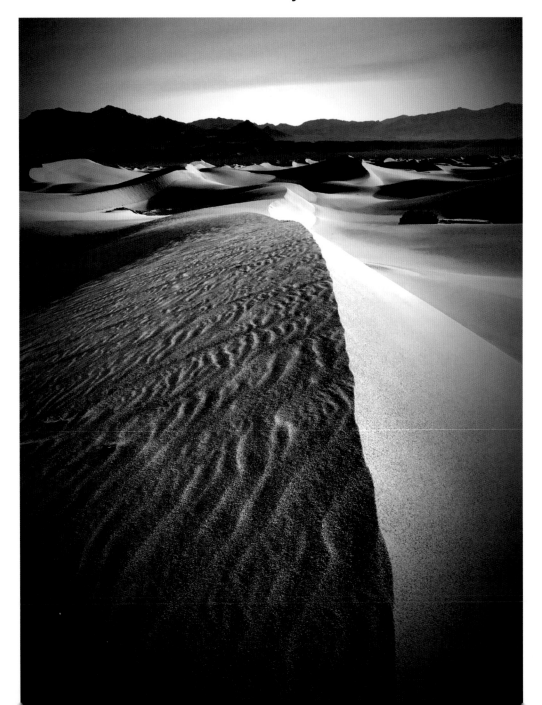

Stately Giants

The site where many groves of red-wood trees have stood the test of time. These stately giants are always of interest, particularly when the light rests on one side only. The effect promotes a three-dimensional look in the image. Notice the tree in the front right of the image. The lighter tone of the foliage contrasts the giants resting near its feathering leaves.

This image was processed using the Hipstamatic app with the G2 Lens and Claunch 72 Monochrome Film filter. The warm tone of this filter adds to the majesty of the image.

Center Tree

When in the redwoods, pointing your iPhone toward the tops of the trees will allow you to capture their height and size. These giants are the star of the photo, with fog and sun in the background showing off a single tree in the strand of many.

This photo was converted to black & white using the Photoshop Express black & white filter. The exposure and contrast were adjusted to obtain the maximum amount of detail in the sky and in the trees.

"Look in all directions to find the best angle."

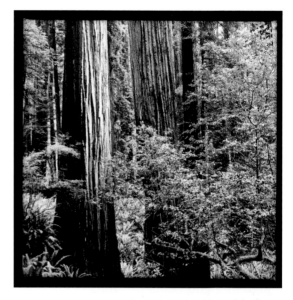

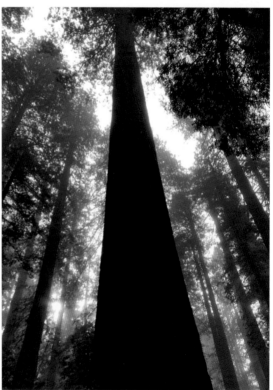

top. **The stately redwoods of Redwood National Park.**

bottom. **The center tree is the star of this image, shot in Redwood National Park.**

Crossing Trees

Walking on the trail to a big tree grove, I saw these two trees crossed over in front of me on the trail ahead and thought it was an interesting sight. Seek unusual lines, patterns, textures, or lighting as you hike through the forest.

Nature has a way of presenting scenery and landscapes that may be surprising and subtle or spectacular and obvious. Being open and ready to capture the drama and beauty in the outdoors with eyes and camera ready is magic.

Processing for this image was done with Photoshop Express and the Pinhole filter.

Light Ahead

Follow the light! When taking photos in the Redwoods, look for great light to lead you to amazing images.

On this occasion, the available light highlighted these trees and made them come alive. In flat light, the image would not have been effective.

When processing this photo with Photoshop Express and the Pinhole filter, I applied a greater amount of darkening on the edges of the image to further enhance and draw the eye to the light between the trees.

left. **Crossing trees in Redwood National Park.**

right. **Captivating light in Redwood National Park.**

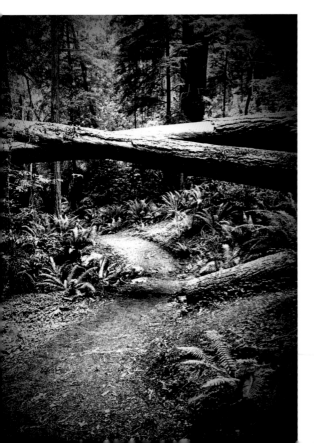 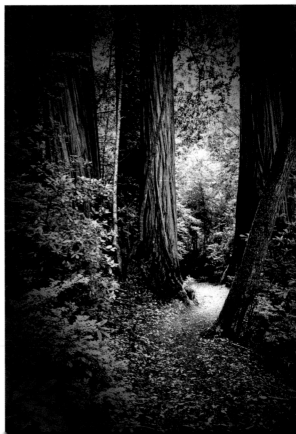

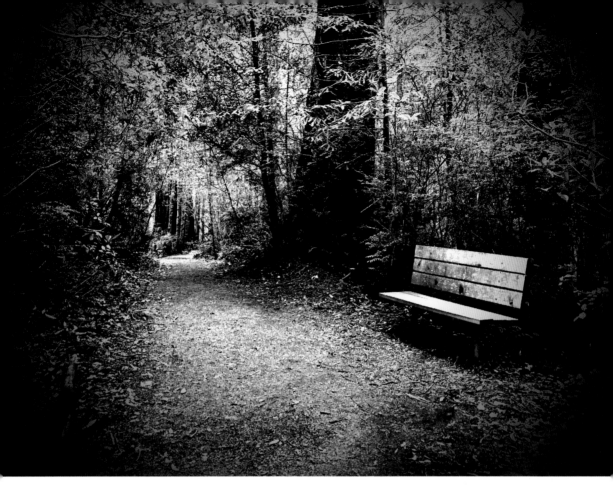

above. **Redwood National Park.**

Resting Place

A place to stop, rest, and enjoy the big trees of the Redwood National Park. This trail, which includes many redwood trees, is located at the Lady Bird Johnson Grove. It is an easy walk. The trail through the grove is only slightly more than a mile of mostly flat landscape. It is a location that should not be missed, if traveling near this northern California park.

The park was dedicated by President Richard Nixon in August 1969. Mrs. Johnson attended the ceremony, as did past presidents. President Johnson and then California Governor Ronald Regan were two of the dignitaries present.

This image was processed using Photoshop Express and the Pinhole filter.

"Side lighting can bring out the texture in your images."

Zion National Park, Virgin River

This image was taken from the bridge that crosses the Virgin River. It is always a popular location for photos at Zion National Park. The mountain in the background is called the Watchman, and there is a well-traveled trail that leads to it.

I used the iPhone's Live Photo feature with the Long Exposure mode to create the softness in the water and still retain clarity in the trees and mountains surrounding it. When using Long Exposure, it is important that you hold your phone as steady as possible to avoid a blurry image.

The image was converted to black & white using the Noir filter.

Emerald Pools

The Emerald Pools in Zion National Park are classic. Take the Kayenta Trail and view the waterfall that comes over the trail. The trail is rated easy to moderate and is a very popular hike in the center of the valley.

This photo, taken in the early morning, captured the sun shining on the veil of water cascading downward, making the water's sparkle prominent.

This image was converted to black & white using the iPhone Mono filter. I adjusted the brightness and contrast to improve the overall tonal range.

Grand Canyon View

This image of the majestic Grand Canyon was taken at sunset when the light maximizes the visual depth and beauty of the canyon. The best time to take photos of the canyon is during the golden hour (the hour after sunrise and hour before sunset). During this time, the light is low on the horizon and has a strong cross-lighting effect, improving the texture of the landscape and giving a three-dimensional look to the scene.

This file was processed with Photoshop Express. I used the Pinhole filter to darken the sky and foreground, drawing the eye to the center and the canyon below.

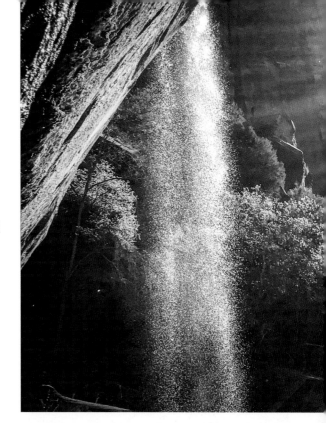

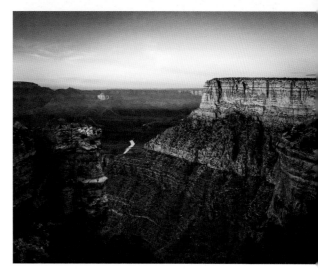

top. **Emerald Pools.**

bottom. **Grand Canyon sunset.**

"Light and motion make for interesting compositions."

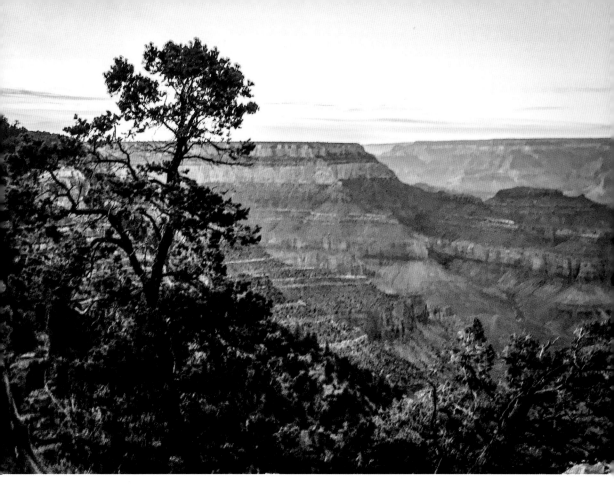

above. **Grand Canyon overlook in evening light.**

Overlook at Evening

The Grand Canyon offers many awe-inspiring overlooks for taking photos throughout the day and early evening. This image was taken in the early evening, giving the tree on the left a darker tone than the canyon in the background.

This image was processed with the ProCamera app and the Gray filter.

"Look for scene tones and brightness levels that offer variation."

Overlook at Morning

This image was taken at sunrise as the sun was filling the canyon with early light. The trees in this image were shaded and became very dark, adding contrast and depth to the image.

The photograph was processed with the Camera+ app and the Noir filter.

South Rim Overlook

This Grand Canyon overlook is located on the south rim and is a wonderful spot to view the canyon with a camera or telescope. This photo, taken in the morning, shows the canyon filled with early light.

The image was processed using Photoshop Express and the Pinhole filter.

top. **The Grand Canyon in early-morning light.**

bottom. **View from the Grand Canyon's south rim.**

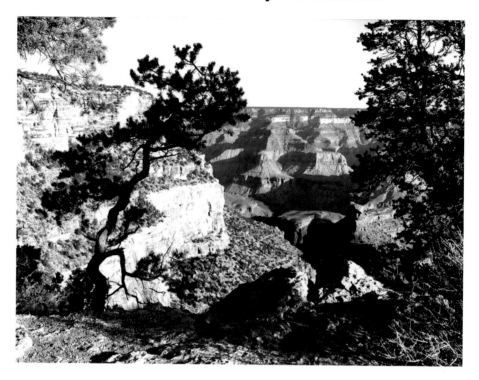

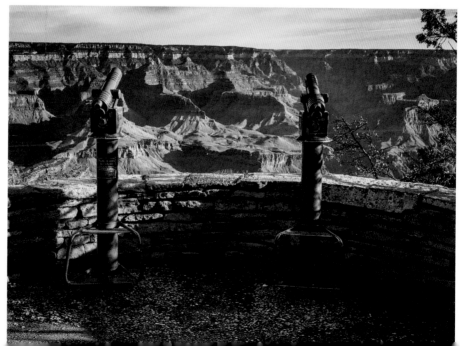

Horseshoe Bend

Horseshoe Bend is not situated in a national park. It is a popular tourist destination located near Page, AZ. The river in the photograph is the Colorado River; its waters are released from Lake Powell, which is upstream from this location.

top. **Monument Valley.**

bottom. **Horseshoe Bend.**

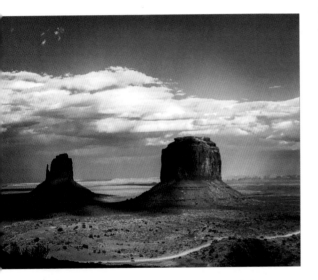

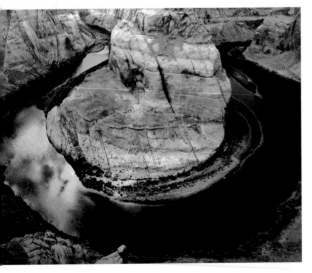

This image was processed with the Camera+ app and the Noir filter. The brightness and contrast were adjusted to improve the overall look.

Monument Valley, Navajo Tribal Park

Monument Valley in Navajo Tribal Park is located on the Utah and Arizona border and is an excellent location for black & white photography. The park contains numerous large rock formations that make for spectacular photos against the wide-open sky. Sunrise and sunset are the best times to photograph the area, adding shadows and contrast to the scene.

There is an unpaved road going through the park that is worth the time to drive. It is the perfect way to see and photograph this magnificent landscape.

This photo was processed using Photoshop Express. The Pinhole filter was applied to darken the edges of the image and highlight the center.

following page, left. **Upper Antelope Canyon.**

following page, right. **Lower Antelope Canyon.**

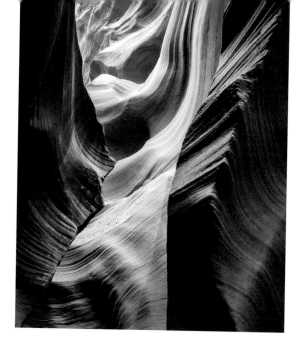

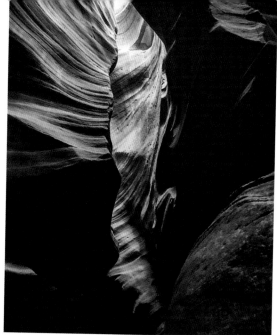

Upper Antelope Canyon

Upper Antelope Canyon is not located in a national park but is in the vicinity of several parks and is a wonderful place to visit. The canyon guided tours are approximately 90 minutes long and give ample time and opportunity to use your iPhone camera. To get the best images, hold your phone as steady as possible, as the light in the canyon may be very low at times and your images may appear unclear if the iPhone moves during the exposure.

This image was processed using the iPhone's Mono filter.

"Abstract shapes and lines make unique photographs."

Lower Antelope Canyon

Lower Antelope Canyon is located within a few miles of Upper Antelope Canyon. Both canyons were created by flood water rushing through the canyon and eroding the sandstone walls. Over the millennia, spectacular shapes and variations of tones in the strata of sand have been revealed.

This image was taken after a lengthy trek into the below-ground-level wonder. The iPhone is the perfect camera to use; it is small, easy to point and shoot, and make many images quickly when below ground. Be sure your phone is fully charged prior to entering the canyon to get the most images.

This photo was processed using Photoshop Express and the black & white Landscape filter.

Seascapes

The United States is bordered by oceans on two sides and peppered with lakes and other waterways throughout its landscape. This chapter includes a large selection of seascape photos taken in a variety of atmospheric conditions and showing myriad tidal effects.

The iPhone camera and related apps give superb results when photographing water scenes, especially when using the latest models of the phone with its Live Photo and Long Exposure features, which allow for the capture of moving water with a silky soft, dreamy appearance. The iPhone can also capture dramatic stop-action photos.

Seascapes offer wonderful opportunities for capturing black & white images of water, rocks, and sand. When on the beach, keep your eyes toward the water and your camera in hand for some exciting photo-taking options.

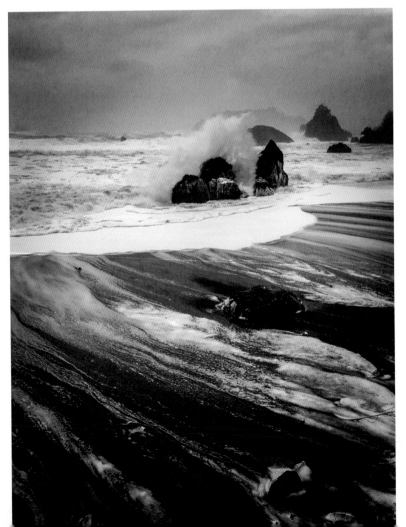

Surf & Rocks

With surf, rocks, and sand, the ocean is a relentlessly changing and powerful force. I never tire of the breaking waves, the rocks being covered by the ocean, or the surf trails that momentarily appear on the wet sand.

left. **Surf and rocks.**

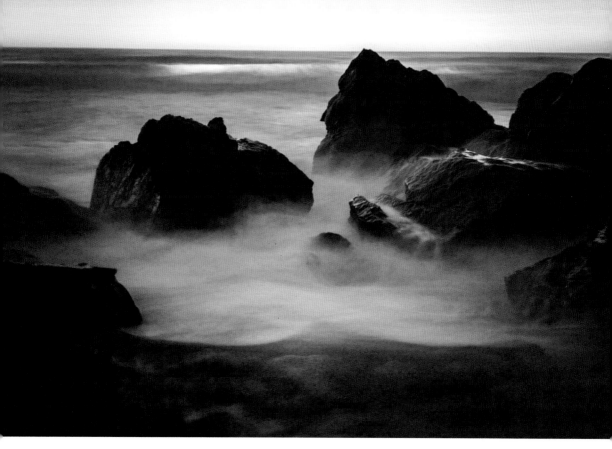

above. **Waves and rocks.**

A cloudy sky often allows the water and surf on the beach to contrast more easily. In black & white photography, light and contrast are the important elements of the photo, as they add interest and drama.

This image was processed with the Photoshop Express app and the Landscape filter.

Waves & Rocks

As eternal as night and day, waves and rocks at the ocean will always be an opportunity for the photographer.

The misty carpeted look of the water is easily created with a newer iPhone camera's Live Photo mode and Long Exposure filter. Hold the iPhone steady to create this type of image, taking several exposures for the best results. This photo was processed using the Photoshop Express app and the Pinhole filter.

"Shoot on a cloudy day for increased contrast between the water and sky."

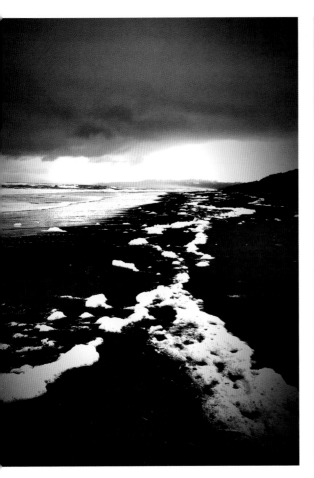

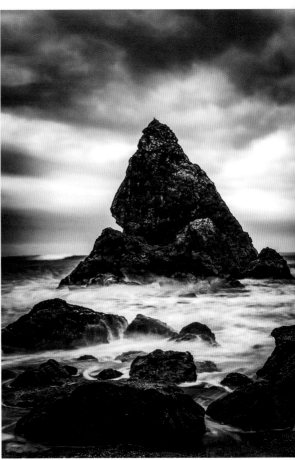

left. **Beach and light.** *right.* **Sea Point.**

Beach & Light

Beachscapes offer endless opportunities for the creative photographer. In this image, the white sea foam leaves a pattern that contrasts nicely against the wet sand. The drama of the dark sky and the canopy of clouds further enhance the mood created within the photograph.

The photo was processed using Photoshop Express and the Landscape filter.

Sea Point

When photographing the sea or a landscape, look for unusual natural elements to create dramatic and uncommon images. This triangle-shaped rock was particularly interesting to me. With the clouds above and the sea below, a perfect composition was created.

I used Photoshop Express and the Pinhole filter to darken the edges of the image and draw the viewer's eyes to the center subject.

Island at Low Tide

The water-and-sand pattern in the foreground and the reflections of the island trees in the water made a striking opportunity for a dramatic image.

When taking photos, look for interesting patterns and reflections. In color photographs, color itself is used to draw attention to individual parts of the scene. With black & white, we must see

"Water and light can lead into the image. Seek them out."

and use lines, angles, and other elements to convey our ideas and produce artful images.

This photo was processed in Photoshop Express using the Pinhole filter.

right. **Island at low tide.**

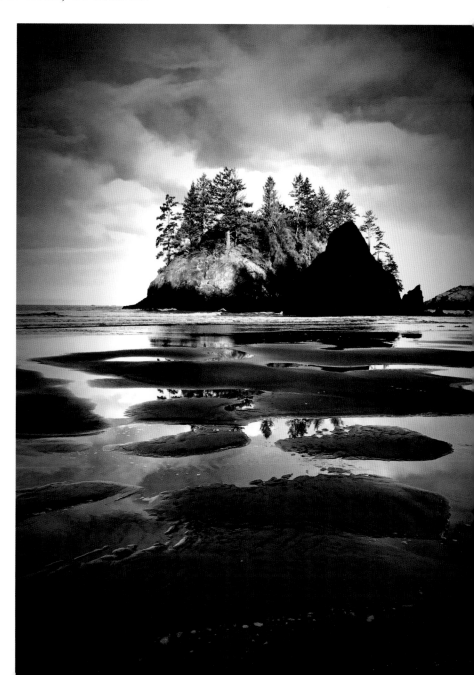

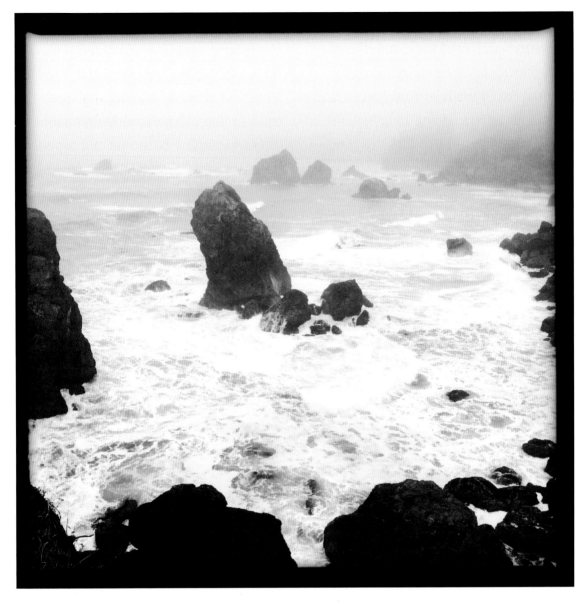

above. **This seaside image was given a vintage treatment.**

Fog & Surf

Inclement weather, turbulent seas, fog, and rough surf create myriad opportunities for amazing images. This image was photographed in a square format, and a warm tone was applied to produce a vintage appearance.

The image was processed with the Hipstamatic app.

"Try warm, sepia tones, or cool tones in your photographs for more image variety."

Lone Sea Stack

This lone sea stack is located in Bandon, OR, and is a favorite location of mine and many other photographers for seascape photography. Taken at sunset, the soft backlighting created an image that is one of my favorites. The exposure time on this iPhone image was $1/500$ second. Using Live Photo and the Long Exposure filter gave the water in the image a soft and mystical look that enhanced the image.

The processing on this image was competed using Photoshop Express and the Pinhole filter.

Path to the Sea

How many times have human feet walked this path to the sea and forced a path where only grasses and shrubs once grew? The bend in the path and the limited view of the sea add a sense of mystery to the image. Viewers wonder what lies ahead to see and experience. The dark trees on the left and the brightness of the water make the sea ahead an inviting place to head toward.

This image was converted to black & white in Photoshop Express using the Pinhole filter.

left. Sea stack, Bandon, OR.

right. An inviting path leads the eye through the frame.

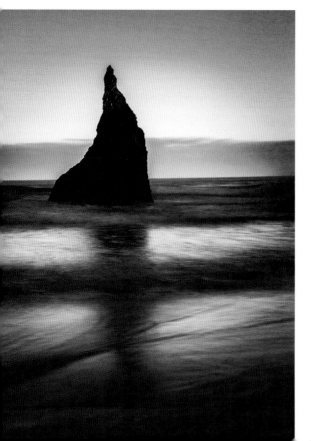
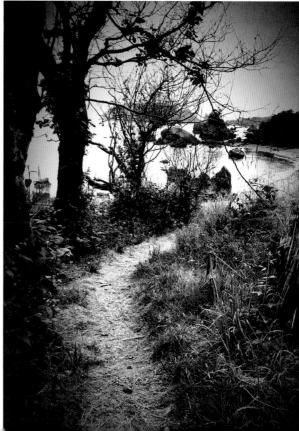

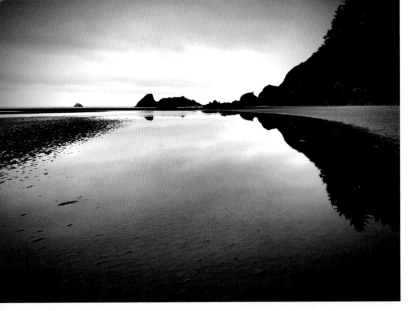

Reflection

Early-morning light and the still and quiet of a newly illuminated sky are magical for the photographer. This large tide pool reflected the sky above, creating a mirror image of the new dawn and drawing our attention to the rising light. The dark sand on the right helps lead our eyes to the sea.

This image was processed with Photoshop Express and the Pinhole filter.

Rock & Light

It has been said that patience is a virtue. In this instance, I captured multiple images until finally rock, sand, surf, and sky came together, creating one remarkable moment.

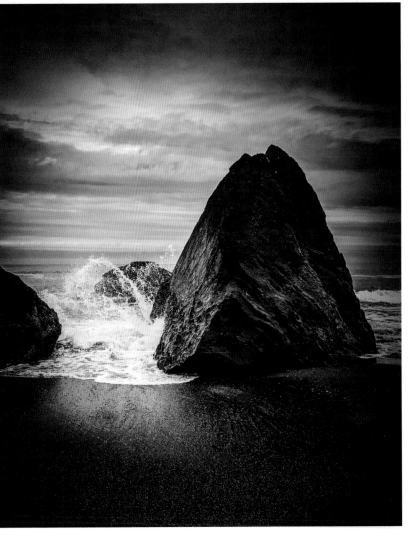

top. **Tide pool reflecting the sky.**

bottom. **A dramatic photo can be a reward for patience.**

This photo was processed in Photoshop Express. I used the Pinhole filter and the Clarity and Dehaze sliders to enhance the photo and give additional contrast to the sky.

Soft Surf

Carefully standing on a rock above the tide and taking many photos led to the capture of this photograph. Composing the image vertically allowed the large rocks on the left to form a border that directs the viewer's gaze to the center of the photo.

The image was taken with the iPhone's Live Photo at $^1/_{327}$ second. I also used the Long Exposure feature.

The original color photo was converted to black & white with the iPhone Mono filter. The brightness and contrast were also adjusted to enhance the detail in the

light water and dark rocks, producing a dramatic and evocative image.

"Create interesting shots with the iPhone's Long Exposure feature."

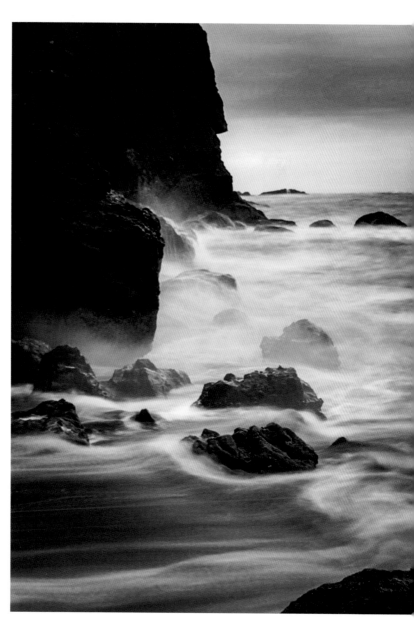

right. The iPhone's Live Photo and Long Exposure features were used to produce this dreamlike image.

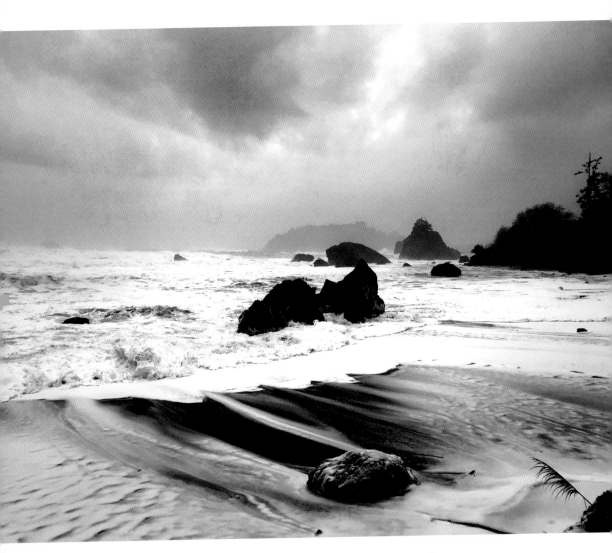

above. **A striking seascape shot in the early-morning fog.**

Morning Fog

On this foggy morning, the surf was high with sea foam on the shore. The clouded sky filtered the light coming through, making it an important part of the image.

To make the best landscape and seascape photos, it is important to include interesting elements and fill the frame. This allows the viewer many items to look at.

This northern California coast image was processed using the ProCamera app and the 003 filter.

Northern California Beach

Plants from the sea often wash ashore and make unique shapes and patterns. The S shape in this image caught my attention as I stood on the beach waiting for the surf to hit the shore again. Also of interest is the small cloud in the upper left that seems to be hanging in the sky with no particular place to go.

This image was processed using the Hipstamatic app, with the Jane Lens and Blanco Film and converted to black & white using the iPhone app and the Mono filter.

Beach & Fog

A blanket of fog covered the early-morning sky when this photo was taken. The stark white surf foam added an excellent contrast to this moody image. Next is lighter sand with white foam and then the sea with its breaking waves leading to the fog and sky. Visual layering techniques are valuable in designing the photo you want to capture.

The image was converted to black & white using Photoshop Express and the Pinhole filter to darken the edges of the image. The brightness and contrast were adjusted to improve the overall look of the finished photo.

"S-shaped curves can lead the eye through the composition."

top. The S shape in this image draws the eye through the scene.

bottom. A high-contrast, moody beach image.

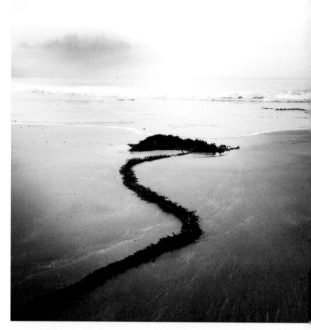

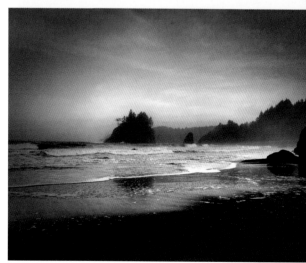

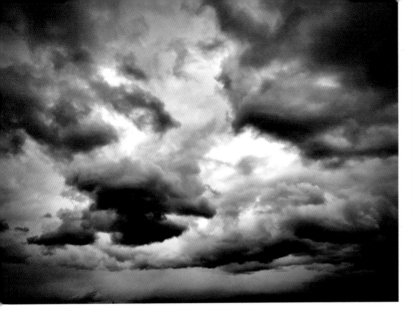

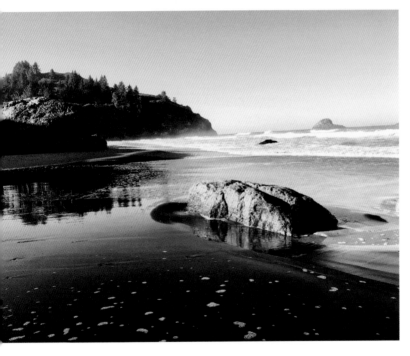

top left. **This image shows the dramatic coastal sky.**

bottom left. **This beach shot was made on a sunny morning.**

above. **Northern California coastal pano.**

Coastal Sky

It was a lucky day to photograph an amazing blanket of clouds traveling across the Pacific north coast. Clouds always command interest, with the changing shapes and patterns they create. These clouds were appealing to me because of the tonal range present across the ominous collection. Dark bottoms indicate a storm is about to happen. When taking images on the beach, rain can happen suddenly. Keeping an eye on the sky and surf is the best way to stay dry and safe.

The image was converted to black & white with the iPhone's Mono filter. The Dramatic Black & White app was used to darken the edges of the image and highlight the center.

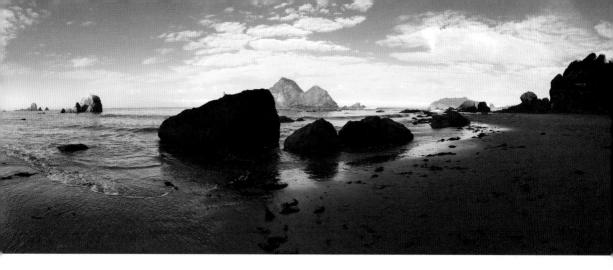

Sunny Morning

Coastal fog was not present on this early morning made for beautiful beach photography. Many reflections and light were on the wet sand.

If you are located on the east coast or west coast, the beach is a wonderful location for taking photos and enjoying time walking in the sand and looking at the beautiful scenery.

In this image, the rock in the foreground brought balance to the composition and created a point of interest to the right side. To make the best photos, search for items to include in the frame that will add varied and remarkable interest for the viewer.

This image was converted to black & white with the iPhone's Silvertone filter.

"Use the camera's Pano option to capture a sweeping vista."

Coastal Panoramic

An amazing feature of the iPhone camera is the built-in software giving the ability to create panoramic photos. Using the Pano feature is easy and only takes one image. However, practice does make perfect when learning how to use the feature properly. To take a pano photo, move the slider on the front of the camera to the Pano position. Next, holding the camera on the same level, follow the arrow on the screen and move the camera from left to right, keeping the arrow on the center of the line. Push the exposure button again at the end of the photo and the camera will process the image to a long and narrow panoramic shape.

This image was converted to black & white using the ProCamera app and the ID 3200 filter.

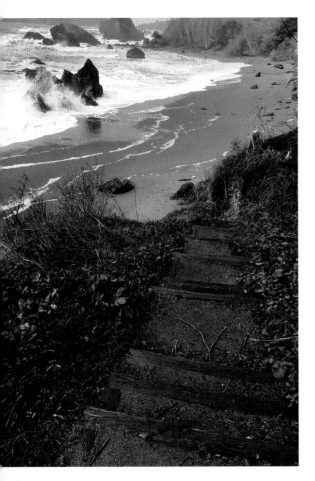

Steps to the Sea

This steps-to-the-sea photo was taken on a cold and foggy day with large surf breaking on the rocks below. The steps were included in the image to give the viewer a better understanding of how the local landscape looks and what path is taken to get to the beach below. The steps were positioned at an angle in the photo to lead the viewer's gaze down to the shore and sea.

This photo was taken with an iPhone 7. The iPhone's Mono filter was used to convert the file to black & white.

Patrick's Point

Due to the high surf and wet, slippery rocks, I used the digital zoom on the iPhone 7 to take this image. The wave is illuminated with the morning sun, which had just crested over the mountain horizon behind me. The light acted as a spotlight on the wave, while the rocks at the bottom of the image remained dark, enhancing the overall look of the image.

Great lighting is an integral part of successful images. Photos taken on subsequent days without the sun were not as pleasing.

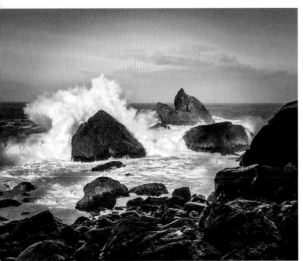

top. **These steps lead the eye to the sea in the background.**

bottom. **Patrick's Point State Park.**

"Use the iPhone to capture images of movement."

This shot was processed with the Camera+ app and the Noir filter. Brightness and contrast were adjusted to improve the overall look of the image.

Calm Morning Sea

On this morning, the seas were calm, and a cloudy sky provided filtered light to reflect in the tide waters on the beach. This image, shot in Bandon, OR, is interesting due to the prominent sea stack on the left and the light-and-dark patterns of water and sand on the beach.

The image was processed with Pro-Camera and the KTR IX filter. Brightness and contrast were adjusted to give greater contrast to the sand and water.

below. **Sea stack in Bandon, OR.**

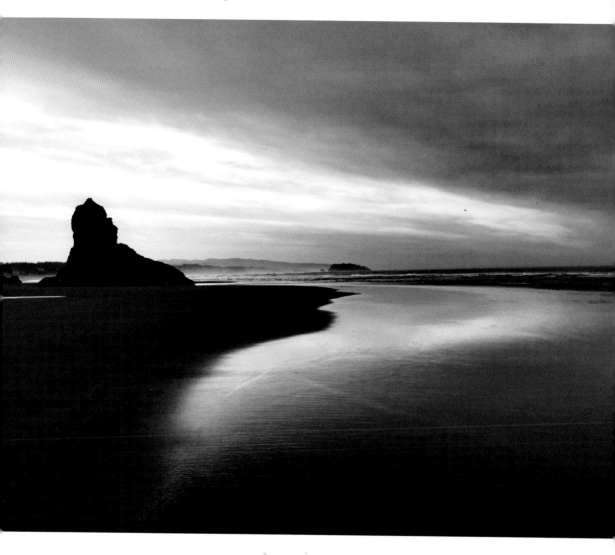

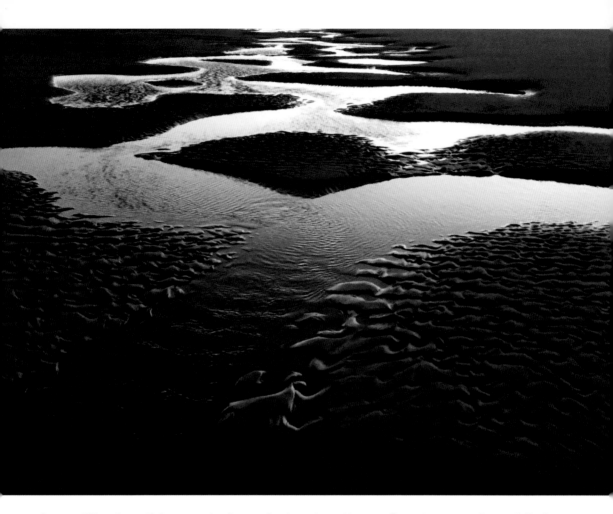

above. **The low tide created an abstract pattern of water, sand, and light.**

following page, top. **Breaking waves at Patrick's Point State Park.**

following page, bottom. **Sunrise on the California coast.**

Tide Patterns

This image was taken on the beach in Bandon, OR, early in the morning as the tide was flowing back to the sea. The result was a spectacular abstract pattern of water, sand, and light.

I have returned to this beach many times since taking this image, but I have never seen this pattern repeated.

The light and sand on the coast is constantly changing, offering different and unique opportunities for one-of-a-kind photos.

This image was converted to black & white using the ProCamera 003 filter. The Camera+ app was used to crop the top of the image—the sky—which presented as a distraction in the photo.

Breaking Waves

The winter season on the northern California coast offers many opportunities for photographing large and spectacular waves, breaking on the coastal rocks. Patrick's Point State Park is a prime location with several overlooks that can be accessed to take images of the pounding surf at a safe and secure distance. Waves of this size may be very dangerous, and you never want to risk standing within striking distance or turn your back to the sea.

On the day this image was taken, the waves were coming in with remarkable speed and power, and I had multiple opportunities to capture shots of the towering waves breaking on the rocks.

This image was processed with the ProCamera app with the 025 filter. The brightness and contrast were adjusted to improve the overall appearance of the image.

Sunrise

Sunrise on the California coast offers many opportunities for seascape photos. In this image, shot in Trinidad, CA, trees and foliage framed three sides of the photo, enhancing the look of the sea, sky, and center rock.

The image was processed with the ProCamera app and the 025 filter. I increased the contrast to create a silhouetted, vintage look. The Snapseed app was used to apply a black frame.

"Create a silhouette image for a dramatic look."

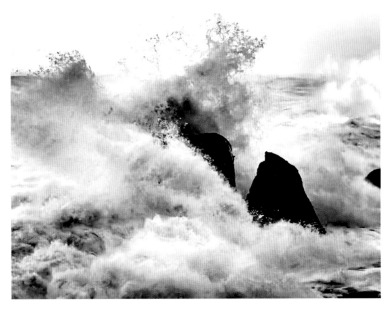

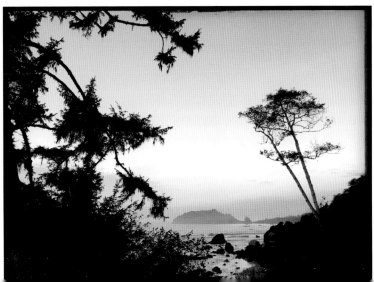

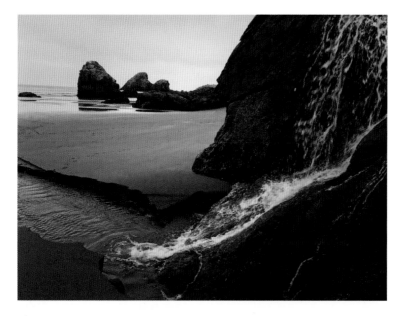

water, and there is no access point available.

The water from the stream creates a small waterfall, and some unusual patterns emerge as it combines with the sand below.

The rocks on the beach were included to balance the tones in the image and give a coastal reference point.

The image was processed with the iPhone Noir filter. The ProCamera Vignette 1 filter was applied to darken the edges of the image.

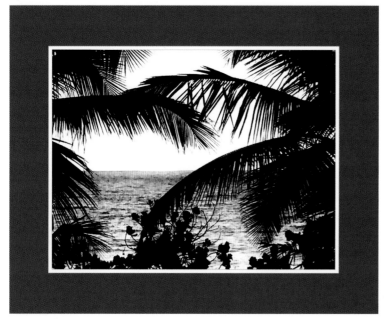

Sea Stream

A small stream in Trinidad, CA, flows over these coastal rocks and heads out to the sea. As the tide was low, the stream and rocks were accessible from the beach. During high tides, the stream is completely immersed by the sea

Palms

Palm trees in Miami Beach, FL, create a frame around a view of the sea. The two center palms were used to cover up a large white area of overcast sky.

The Snapseed app was used to create the silhouette, and the Camera+ Double Mat was applied to frame the image.

Calm Beach

This image was taken in the early morning while the sun was hidden by coastal fog and clouds. The tide was low as it gently rolled over the sand of the large and open beach.

The image was taken in central Oregon using the iPhone 6 camera.

Use of the Hipstamatic app using the G2 Lens and the Claunch 72 Film filter for black & white conversion led to the photograph seen here.

"Add a dark frame to enhance your image."

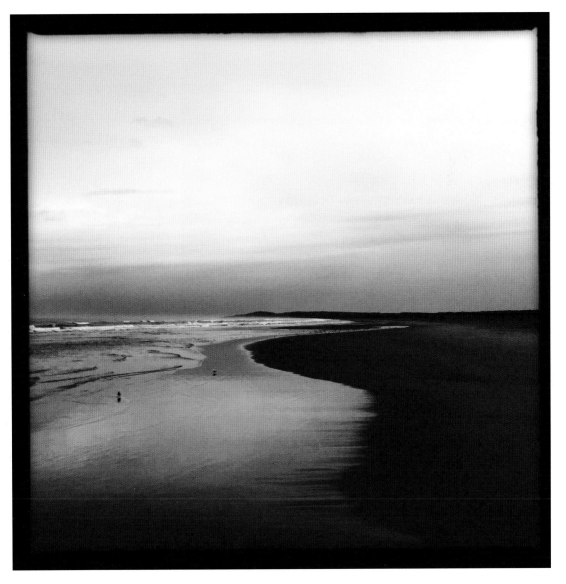

above. Coastal fog and clouds set the scene for this calm beach image.

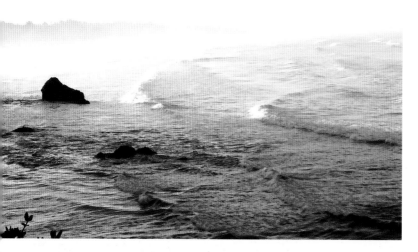

morning sun. The calm tide rolling in offers another glimpse into the ocean's ever-changing seascape.

The ProCamera app and ILP 50 filter were used to convert the image to black & white.

Camel Rock in the Distance

This image was taken off of the coast of Trinidad, CA. It is a popular location for surfers year around. The tide was coming in quickly at the time this image was taken. The fog was thick and blanketed the sky. When the tide is low and channeling out, it is easy to walk around the center rock, taking images and enjoying the beauty of the area.

This image was processed with the ProCamera app and APX 100 filter.

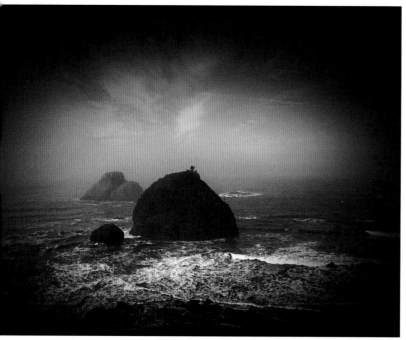

Morning Surf with Fog

The surf along the northern California coast is variable and never dull. This image, taken at sunrise, shows low fog over the water and the light of the

Rock on Rock

When taking photos, I always look for singular and unusual displays in nature. This rock, located in a large open area, sits alone. How and why did it come to this location?

The photo was taken on the Oregon coast in Shore Acres State Park. It was converted to black & white with Photoshop Express and the Pinhole filter.

Two Rocks

This image was taken at Bandon, OR. Numerous spectacular rock formations located just on the coast exist, creating multiple photographic opportunities. The reflections and patterns in the sand are constantly changing. The beach in this area is wide, and when the tide is out it is possible to get close to many of the rock formations.

This image was processed with the ProCamera app and the Tenderloin filter.

"Look for singular and unique displays in nature."

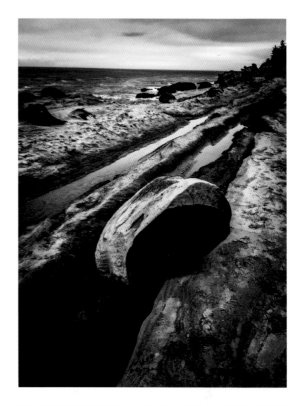

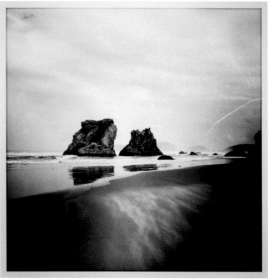

top. A lone rock on the Oregon coast makes for a compelling composition.

bottom. These rocks command attention and provide a dramatic subject.

Urban Life

The chapter includes landscapes of the city and documents human involvement in the natural landscape. The urban landscape, a man-made location, lends itself beautifully to black & white photography. Tall buildings, streets filled with cars, and city parks all fall under the category of urban life.

Some photographers believe that landscape photography encompasses only natural and wilderness areas; however, landscapes are located wherever the land is found, regardless of how it may be altered. Cities show a cultural landscape and how man has changed the surface to fit current needs and desires. This alteration is an ongoing, timeless process.

Photographers have been making images of cities since the advent of the first camera. We prize those images as we explore their content of days gone by. When walking the streets of your own city or town, use your camera and record its cultural history and current condition. Your images of streets and buildings may be studied by future generations.

below. **San Francisco's Bay Bridge.**

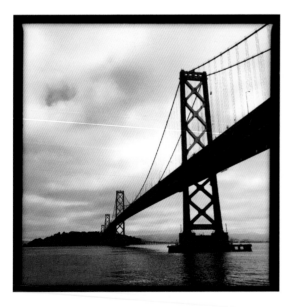

Bay Bridge

San Francisco has two spectacular bridges. This is the Oakland Bay Bridge, and although it is not as renowned as the Golden Gate Bridge, it is easily recognizable.

There are many good viewpoints for taking images of Bay Bridge. I captured this one from near the ferry building on the northwest side.

This photo was taken in the morning, with low clouds in the sky. I used a square format to emphasize the lines

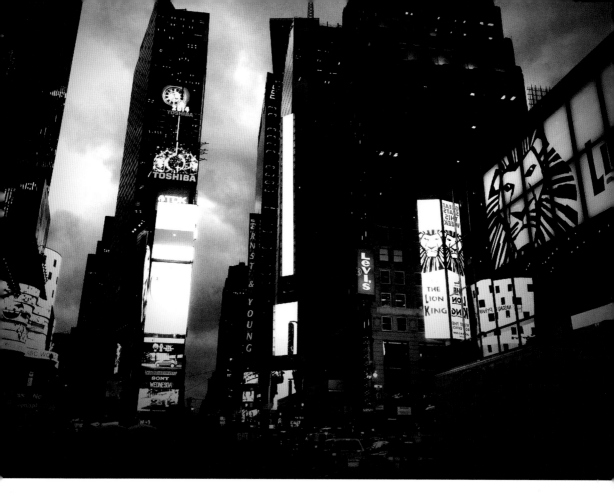

above. **New York's Times Square.**

and shape of the bridge across the image. The Hipstamatic app, Jane Lens, and Claunch 72 Monochrome Film filter were used to make the shot black & white.

Times Square

New York City is an exciting location for photography. At any time, day or night, thousands of people fill the streets, talking, looking at the sights, and taking photos. The iPhone is the perfect camera to use in this crowded location due to its small size and ease of use.

This image shows the size of the buildings and the many lights and signs in the city against the sky.

I used the Dramatic Black & White app to highlight the center of the photo and darken the edges.

"Take photos day or night. Hold your phone as steady as you can for clear images."

J. C. Nichols Memorial Fountain

J. C. Nichols Memorial Fountain is located in Kansas City, MO, near the Country Club Plaza. An interesting photo from several directions, this image *(left)* was taken against the evening sky. The setting sun illuminated the top of the water in the fountain display.

Live Photo and Long Exposure were used to produce the soft look of the water, giving the image an artistic look. The photo was processed using Photoshop Express and the black & white High Contrast filter.

A second view *(right)* shows the entire fountain. The center spray highlighted by the sun become the attraction. As I photographed the fountain, I walked around it, taking images from every direction. This fountain (and the park surrounding it) is a popular spot for people to gather and converse. I chose to highlight the fountain and not the people enjoying the park and its amazing fountain.

This photo was captured using Live Photo and the Long Exposure filter.

left and right. **J. C. Nichols Memorial fountain.**

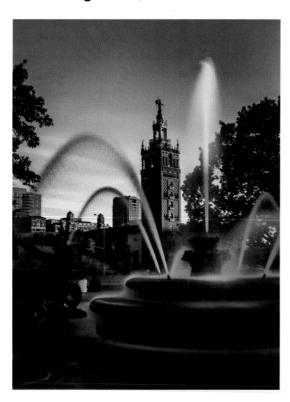 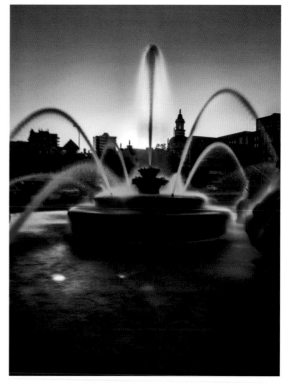

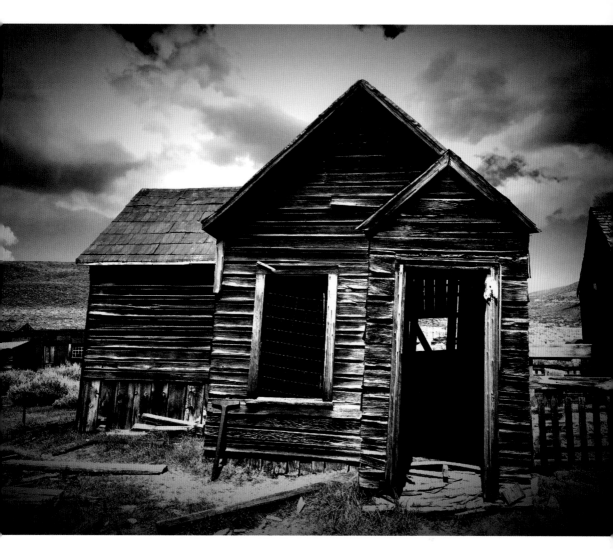

above. **A moody image of an abandoned home in a California ghost town.**

Bodie

This old house is in the ghost town of Bodie, CA. This historic state park is a popular location for tourists and photographers, and there are many old and preserved buildings to photograph.

I found this old house intriguing. I liked the texture of the weathered wood and the light in the window in the back of the vacant house. The many clouds in the sky added atmospheric interest to the background.

The photo was processed with the Photoshop Express Pinhole filter.

> *"Look for ways to add atmospheric interest in your images."*

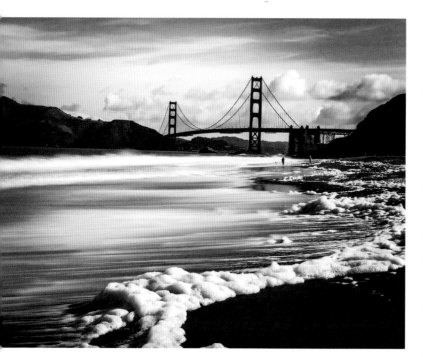

Golden Gate

Golden Gate Bridge, San Francisco, is recognized the world over. This image was made from Baker Beach, looking east toward the bridge. Taken in the early morning with clouds resting in the background, the sea foam and tide in the foreground made for a perfect shot.

The image was taken in iPhone Live Photo, and I used the Long Exposure filter to give softness and interest to the water. The image was processed using the iPhone Mono filter.

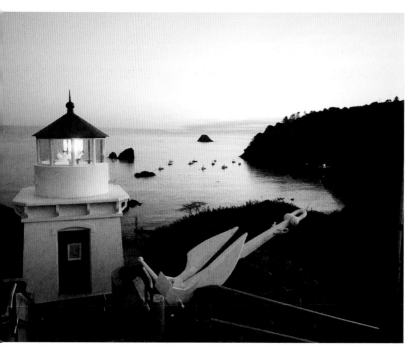

"Include interesting foreground elements to add depth to your photographs."

Lighthouse

My favorite California coastal community, Trinidad, is in northern California about 80 miles from the Oregon

border. The town has a small harbor and a wonderful pier for fishing and sightseeing.

This image was taken at sunset, looking down at the harbor with a few boats below. Unfortunately, the lighthouse has now been moved from this location due to ground movement; however, there still exists a great view of the harbor. I processed this image using iPhone Noir filter.

Ships & Boats

Ships and boats photographed off the coast of Maine. I found the placement and size differences of these boats and ships to be of interest. The cruise ship in the background is a massive vessel in comparison to the boats in the foreground of the image.

When I took this photo, I had just come back from a tour around the harbor on the four-masted ship shown in the middle of the photo. Taking photos on family vacations is always fun.

I used the Camera+ app to process this image with the Noir filter for black & white. The Dark Grit filter was also used to give it more of a painterly look. When processing your iPhone images, try different apps and filters to create more interesting photos to share with friends on social media. I post many images to social media while traveling for friends and family at home to see.

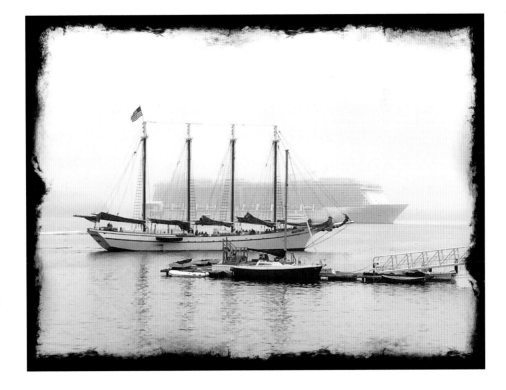

right. A lovely grouping of boats and ships off of the coast of Maine.

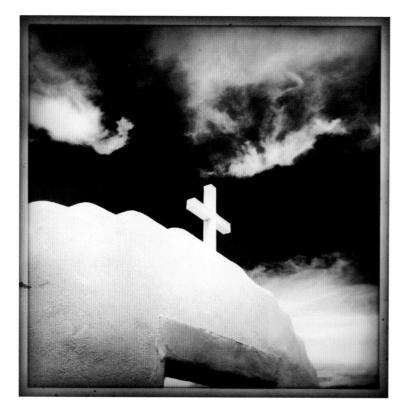

Stow Lake

This little lake built in the park offers a variety of recreational options. Row boats and paddle boats offer a fun way to see the lake from a different perspective. I liked this view *(following page, top),* as the dock leads into the photo and gives the boats a good base location. As I was taking the photo, I adjusted the composition to include the clouds in the sky and the reflection in the water. The dark foliage in the back right of the image draws the viewer's eyes to the center of the photo.

Landscapes come in all shapes and types. Both the wilderness and local parks can make interesting photos worthy of sharing.

The one thing I would change in this photo is the small white item on the dock on the left; it is distracting and needs to be cropped out of the photo.

This image was processed with the iPhone camera software; I converted it to black & white with the Noir filter.

Old Church, Taos

The New Mexico landscape is dotted with historic churches and buildings that are remarkable in appearance and lend themselves well to the black & white medium. In this scene, the cross against the sky was of interest. The sky and clouds in the background added to the overall dramatic and vintage appeal of the photo as well.

I used the Hipstamatic app to process this image in a square format. This approach allowed me to isolate the subject, the cross, and remove unneeded parts of the scene. The Jane Lens was used with Blanco Film to create this look.

When I was walking and taking images in the park, it started to rain, and I took cover under a big tree. Waiting for the shower to pass, the view from under the tree included the lake and the spiky vegetation next to it. I liked the overall look of this scene in the rain and decided to use the TinType app to give this second Stow Park image (bottom) an antique look.

*"Try something new.
Seek out unusual compositions."*

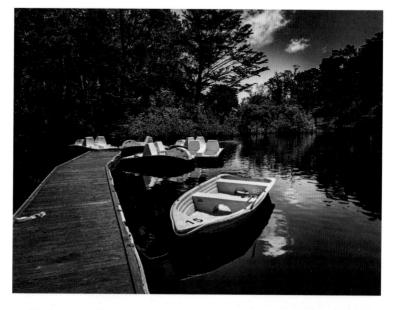

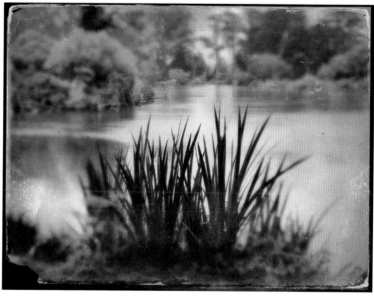

top. **Stow Lake, Golden Gate Park, San Francisco.**

bottom. **Stow Lake detail.**

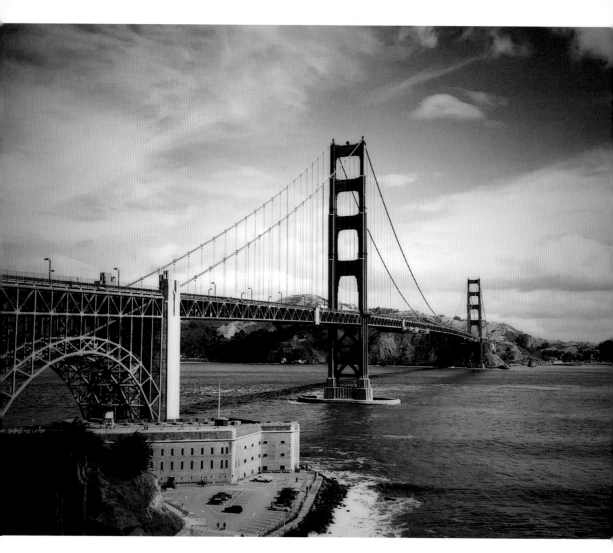

above. **The world-famous Golden Gate bridge.**

San Francisco Treat

Golden Gate Bridge, San Francisco. I will never tire of this magnificent bridge. This shot was made looking west from the walkway near the bridge, but from any direction, it is an amazing sight.

The bridge, water, and sky worked together to make a wonderful photo of this iconic attraction. I found making this image in black & white a perfect way to enhance the lines and structure of the bridge and give it a historic look.

I applied the iPhone's Mono filter and made brightness and contrast adjustments to enhance the tonal values in the image.

top. **A drive-in that time forgot.**

bottom. **A man-made bridge surrounded by lush vegetation.**

Old Drive-In Theater

Located somewhere in the west, this old drive-in theater caught my attention as I was driving the backroads of America. Across the country, there are multitudes of old buildings of every shape and size waiting to be photographed.

I was drawn to the screen's look against the clouded sky. I thought the missing panels of the screen provided an interesting pattern.

This image was processed using the iPhone's Noir filter.

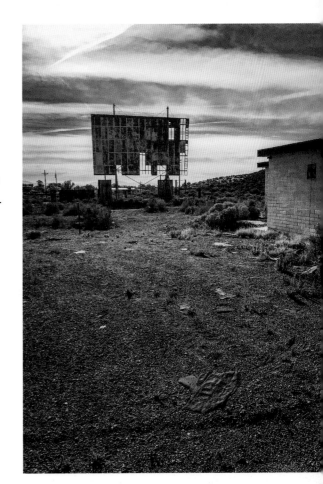

Bridge in the Woods

The only reason that this image is included in the urban landscapes chapter is that this is a man-made bridge in an otherwise natural setting. It is located on a California coastal trail surrounded by ferns and other lush vegetation. I chose to convert this photo to black & white and highlight the bend of the trail and the posts and rails of the bridge. The trail was deserted on this day except for me and my iPhone.

"Draw the eye with areas of strong contrast."

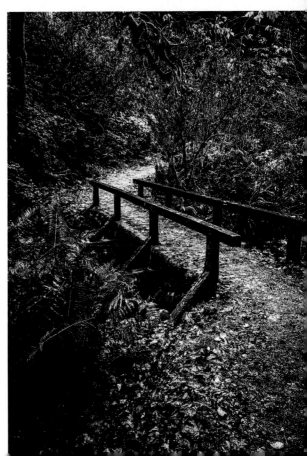

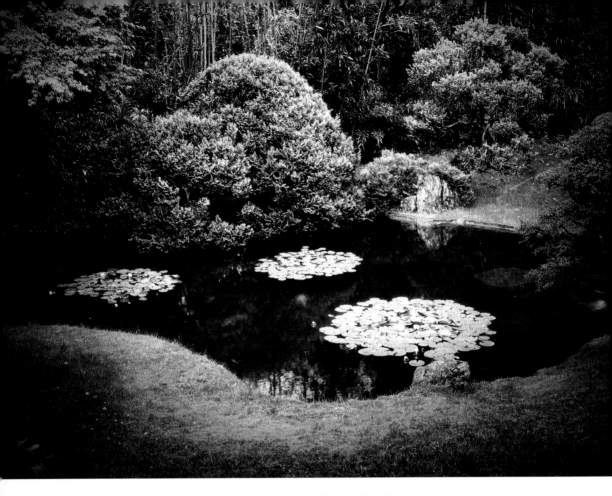

above. **Japanese garden, Golden Gate State Park.**

Japanese Garden

This is a lovely and peaceful section of the Japanese Gardens in Golden Gate Park, San Francisco. It has many ponds and manicured tranquil scenes.

Photos that contain abundant green foliage are among the most difficult to successfully convert to black & white. The light on this day was soft and added a wonderful glow to the lily pads. Looking to effectively capture the small pond and the pattern created by the triangle of lily pads, I processed the image using the Dramatic Black & White app. This allowed for enhanced separation between the green tones and increased the contrast.

"Use the Dramatic Black & White app to improve tonal separation."

Las Vegas Strip

Las Vegas is home to radically different architecture and a skyline that grows ever larger with time. Day or night, the Las Vegas Strip is an urban jungle, full of wild and exotic buildings, flashing lights, fountains, and people. It is a colorful and exciting city.

This image, taken from a window in a hotel room high above the ground, illustrates the jumble and varied heights of the skyline. Removing the color from the photo allowed the shapes and lines of the city to be revealed.

The image was processed with the ProCamera app and the 003 filter.

below. **Las Vegas: the city that never sleeps.**

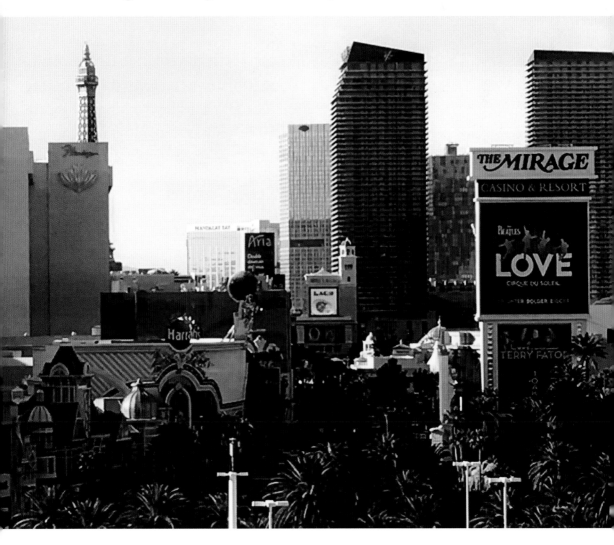

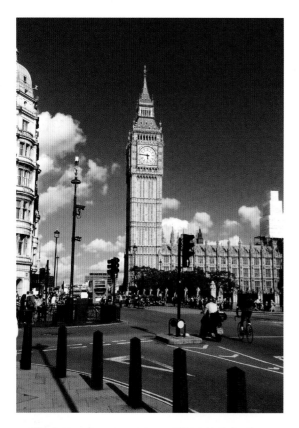

Big Ben

Big Ben is one of London's most famous landmarks. The name refers to the bell in this iconic tower, located at the north end of Westminster Abbey.

This image *(top),* taken from street level, shows the impressive size of the clock tower. The dark sky and puffy white clouds add to the drama of the scene.

The sky in the color image was dark blue, which was converted successfully to a dark tone using the iPhone Noir filter. The contrast was further enhanced to bring out the brightness of the clouds against the very dark sky.

Here's a second interpretation *(bottom)* of Big Ben using the TinType app and a brown filter.

The world-renowned clock tower was completed in 1859 and stands 315 feet tall. When in London, this is a sight not to be missed. The tower is also a popular background for a selfie!

"Apply unique effects to make your photos sing."

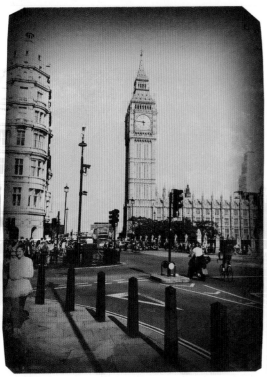

New York City

This image, taken from the top of the Empire State Building, captures the massive size of this spectacular city. This view looking toward the East River included the clouds, which added a moody feel to the image.

When visiting the Empire State Building's 86th-floor observation deck, you may take photos in all directions. The wire fence around the deck doesn't impede the view.

This image was processed with the Hipstamatic app, Jane Lens, and Blanco Film. A square format was used to highlight the river.

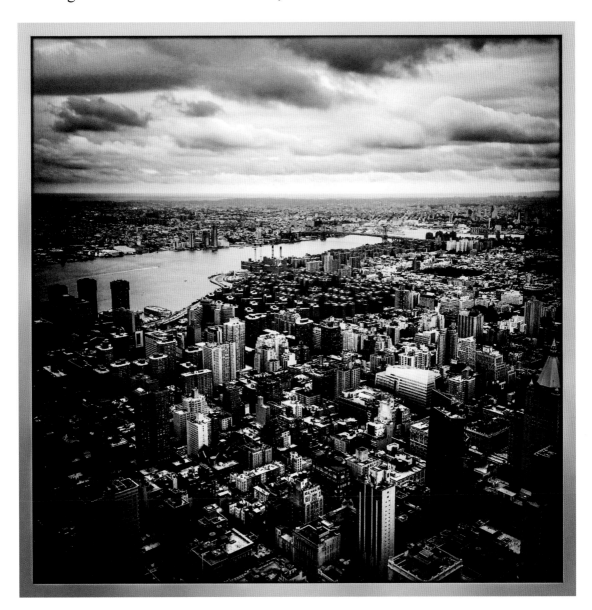

above. **The impressive New York City urban landscape.**

Old House

Abandoned homes and buildings are located throughout our country. These buildings, often simple structures, standing alone, weathered, and bleached, offer a mystery or perhaps a brief view of the past.

This image was taken from the rear of the old homestead. The front porch is on the left, and the light can be seen illuminating the home, seemingly from the inside out. The grass in the foreground has been left to grow free.

The image, shot in northern California, was captured with an iPhone 7 and converted to black & white using Photoshop Express Pinhole filter.

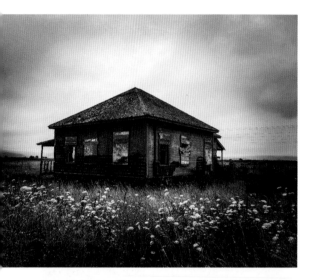

Lithia Park

Lithia Park in Ashland, OR, is popular with locals and tourists. Ashland is famous for being the home of the Oregon Shakespeare Festival, and Lithia Park is located near several theaters in the downtown area.

This image was taken in the peak of fall when leaves were dropping from the trees. Most of the images in this book are of scenes that lacked significant color. This image is an exception. The vivid yellow leaves, when converted to black & white, became a light shade of gray and contrasted well against the dark wood of the bench.

The image was converted to black & white using the ProCamera app and the 003 filter. Brightness and contrast were also adjusted to produce the best tones for the image.

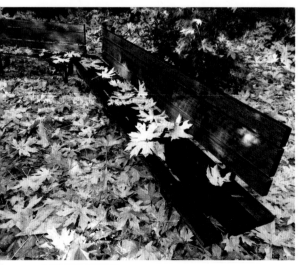

top. A striking abandoned home in a picturesque setting.

bottom. Lithia Park in autumn.

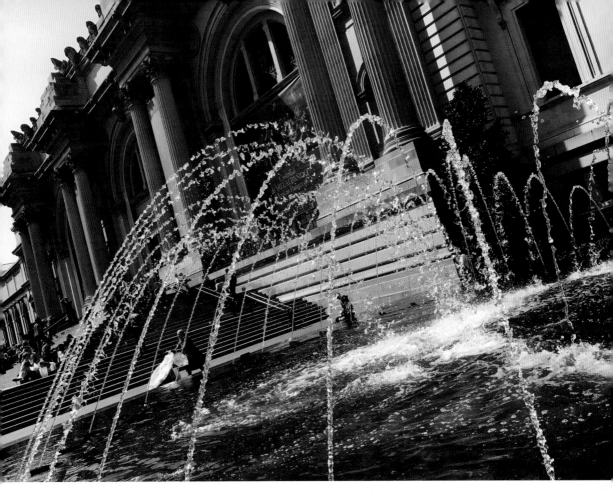

above. **One of the numerous fountains outside of the Metropoliatan Museum of Art.**

Fountain at the Met

The Metropolitan Museum of Art, founded in 1870, is one of the oldest and largest art museums in the United States. Located on Fifth Avenue, this impressive building is landscaped with several spectacular fountains.

This photo, taken from a low angle, captured the spray of the fountain and the building's exterior. The building is at an angle to complement the angle of the water spray and the pool.

Architecture is an important part of the urban landscape and defines how man has altered the land to serve his social and cultural needs.

This image was made with an iPhone 7 and processed with the Camera+ app and the Noir filter.

"Work those angles to create compelling images."

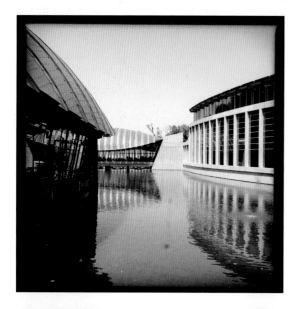

art-loving tourists. The museum has several significant buildings and beautiful grounds around them.

This image displays a water feature that surrounds several of the buildings. The reflection of the buildings adds a creative addition to the photo.

The photo was processed using the Hipstamatic app with the Watts Lens and Claunch 72 Monochrome Film filter.

Museum of Modern Art

The Museum of Modern Art in New York City is another amazing museum. This image was taken in the interior of the museum, looking up a stairway and out of a frosted window. Trees surround the exterior of the building. The lack of clarity and definition in the trees creates a scene of visual interpretation, in a similar way that one may look at the many pieces of art housed in the museum. As we view and capture landscapes with our iPhone camera, being open to new ideas and subjects will lead to new and exciting images.

This image was processed with the ProCamera app and Street/Tenderloin filter for added contrast.

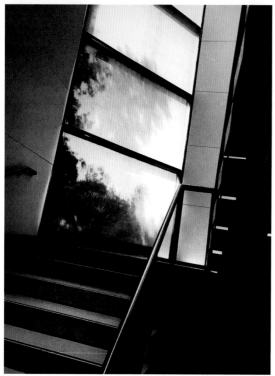

Crystal Bridges

Crystal Bridges Museum of American Art is located in the city of Bentonville, AR. The museum was completed in 2011 and is a popular location for

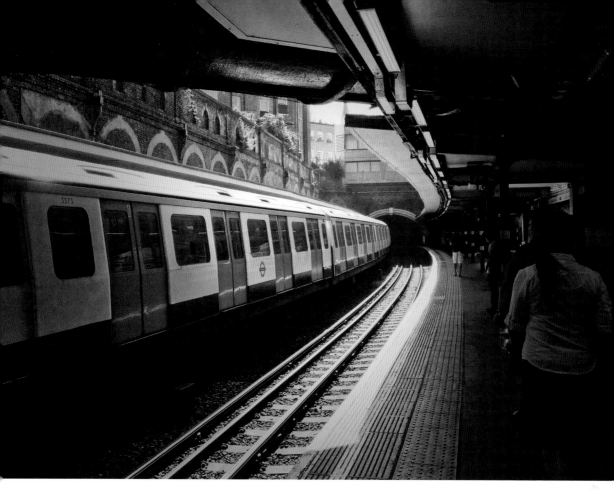

above. **Underground trains have long been used in London, England.**

Underground, London

Underground trains travel below the streets of London, England, and were first established in 1863. Located far below ground level with no natural light to illuminate the trains or stations, the location may make one feel a little claustrophobic.

This image, taken at a station that had exposure to sky light, has an eerie feeling that enhances the tracks next to the train.

This photo was processed using the ProCamera app and the 003 filter. A vignette was applied to darken the edges of the image and highlight the center.

"Capture landscape photos in unlikely locations."

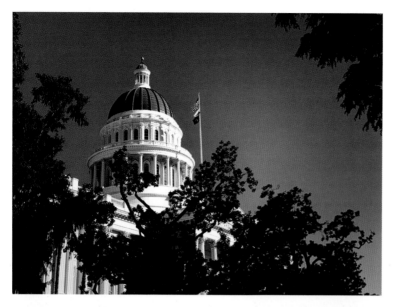

contrast to this large, light-toned building.

The image was processed with the Pro-Camera app and 003 filter, and a vignette was applied to darken the sky and trees.

Olives

This image was taken in Corning, CA. Corning is a large producer of olives and olive oil products. The photo was taken after a rain storm that left a large pool of water in the street. The reflection is the subject of the photo.

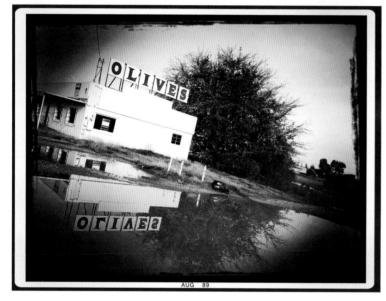

California State Capitol

The State Capitol building of California is located in the center of Sacramento. An urban area, the classic, stately building is surrounded by a park and trees.

The afternoon light illuminated the side of this building, giving it shape, depth, and detail. The trees in the foreground are silhouetted to give

The shot was processed in Hipstamatic with the Lucifer VI Lens and Rock BW-11 Film filter for a vintage look reminiscent of years gone by.

"Make a reflection the subject of your photograph."

Street Scene

The urban landscape features many looks and styles. In New York City, vendors are known to place objects for sale on the sidewalk, as a lead into their businesses. This type of image is recognizable to people from cities around the world, though the contents of such a display may vary depending on the customs and norms in each locale.

This image was processed using the ProCamera app and the Street ID2 100 filter for black & white conversion.

below. **One of New York City's unique commercial displays.**

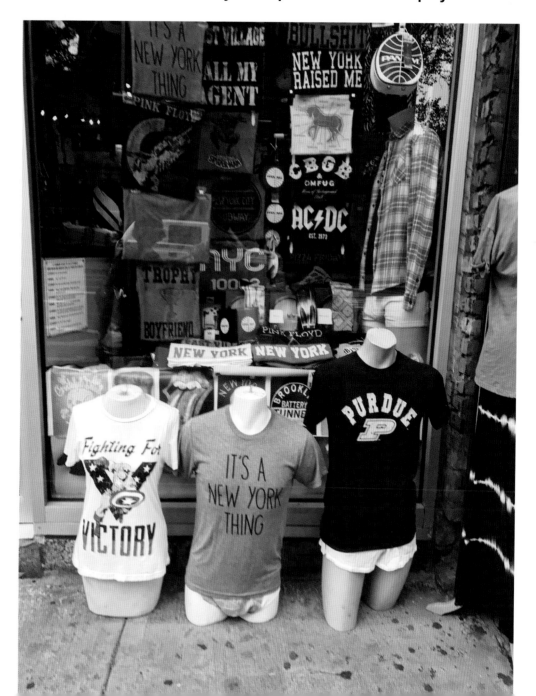

Trinidad Lighthouse

The Trinidad Memorial Lighthouse was erected in 1949 and has many plaques affixed to it as a reminder of those lost at sea over the years.

This image was processed with the TinType app, providing a storytelling aged and antique appearance.

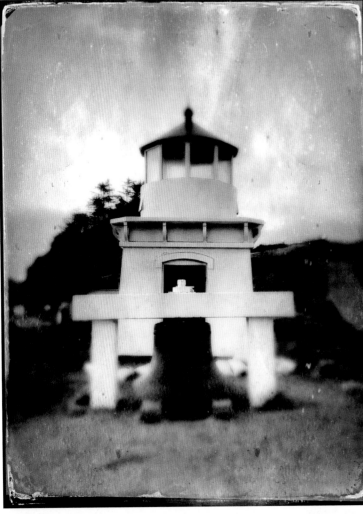

top. **Trinidad Memorial Lighthouse.**

bottom. **This rope and float make for a highly textured image.**

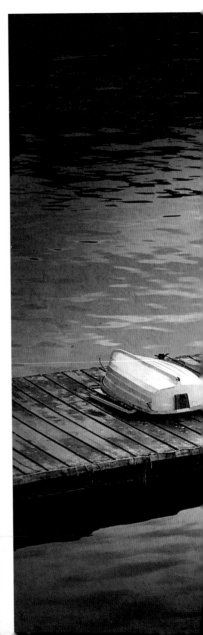

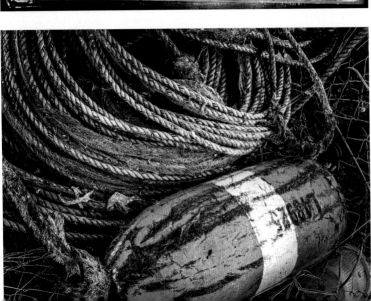

Rope & Float

This rope and float are attached to a crab trap that is dropped into the sea. Both of the items are well worn from years of use and now sit waiting for the next fishing season.

The file was processed with the Photoshop Express Pinhole filter. The brightness and contrast were adjusted to enhance the look of the image.

below. **Fishermens' boats.**

Four Boats on the Dock

These small boats sitting on the dock are used by fishermen to travel to their larger boats in the harbor. The morning light reflected off of the sea, adding contrast to the photo.

This image was processed with the Dramatic Black & White app. I reduced the circle of light to highlight the boats in the photograph.

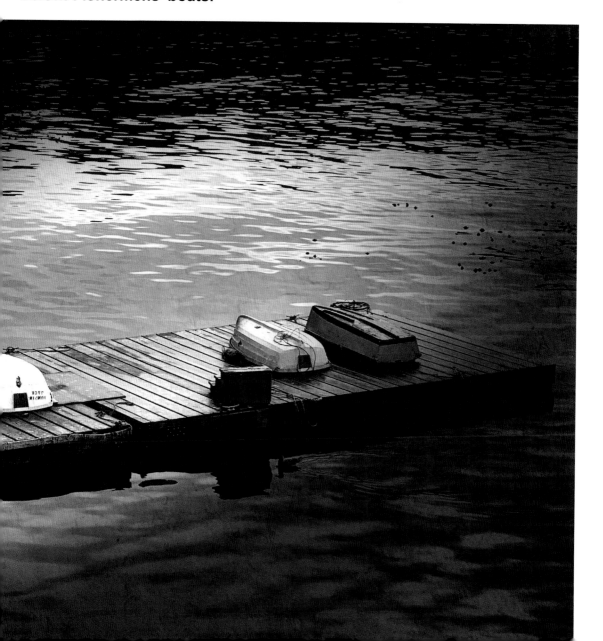

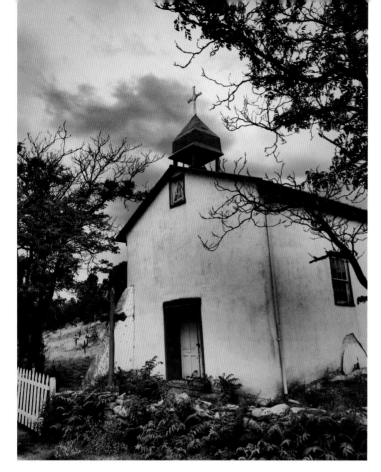

Santa Fe Church

This old church is located near the city of Santa Fe, NM. The simple structure with adobe walls, common in the area, reflects the Spanish influence on its style. The church was constructed in 1880 and has a small cemetery next to it.

This image was taken with an iPhone 5 and processed with the iPhone's Silvertone filter.

Beach Hut

Huts like this one line the beaches in Miami, FL. When open, they supply chairs and drinks to the people who frequent the beach during the day.

This photo was taken early in the morning before the crowds arrived for a day of fun. It was processed using the Hipstamatic filter and Jane Lens with the Claunch 72 Film filter.

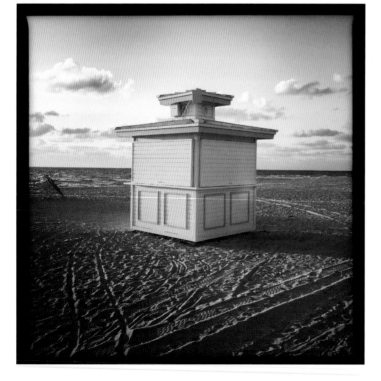

top. **Adobe church outside of Santa Fe, NM.**

bottom. Beach hut in Miami, FL.

Sphere

This concrete ball is located in Golden Gate Park in San Francisco. Park construction began in 1871, and many architectural decorations have been added over the past 150 years.

This image was taken with an iPhone XS and was processed using the Photoshop Express Pinhole filter.

right. Decorative element in Golden Gate Park.

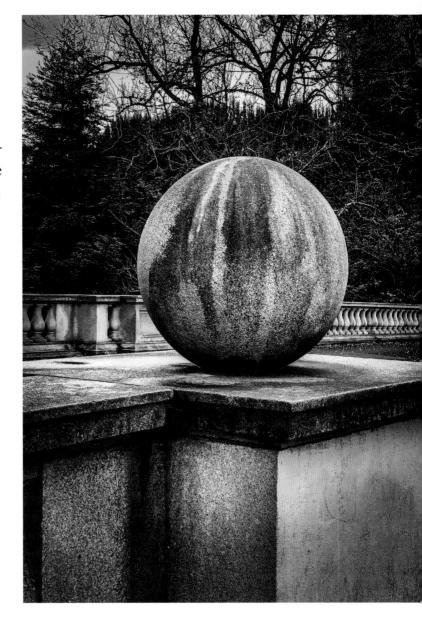

"Strive to create a feeling of compositional balance in your landscape photographs."

Nerman Museum

The Nerman Museum of Contemporary Art is located in Overland Park, KS, on the Johnson County Community College campus. The modern architecture of the building creates a wonderful setting for the collection.

On the day this photo was captured, afternoon light was shining on the side of the building in stark contrast to the tree in the shade next to it. The image was taken in winter, showing the beauty of the stark trees without their covering of leaves.

The image was processed using the ProCamera app with the APX 100 filter.

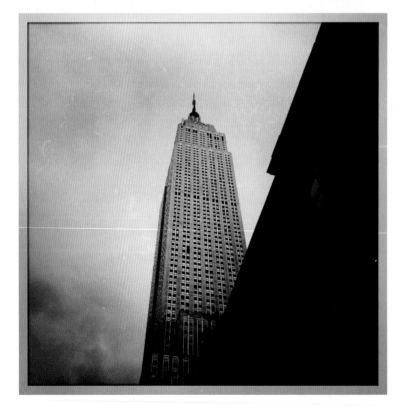

Empire State Building

New York City's Empire State Building is 102 stories tall and was completed in 1931. It is a popular attraction, with about 4 million tourists per year visiting the building.

The image was processed with the Hipstamatic app and Jane Lens.

top. **Nerman Museum of Contemporary Art.**

bottom. **New York's Empire State Building.**

right. **Agriculural landscape, northern California.**

The ProCamera app was used with the Tenderloin filter to produce the color to black & white conversion.

Trucks in a Field

Behind the gate are two trucks used for hauling. The sky is sunny and clear, and the field has been cleared. Scenes like this are common across the United States on all types of land producing agriculture goods for market.

This image was taken in northern California using an iPhone 6 camera. It was processed with the ProCamera app and ID Ortho filter. The Camera+ app was used to add a Light Grit frame on the image.

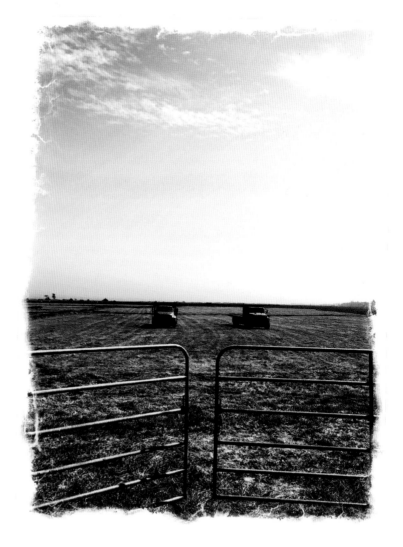

"Consider adding a unique frame that enhances the mood of your image."

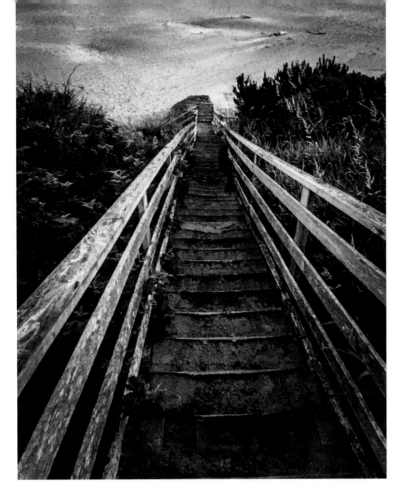

Stairway to the Sea

This old and long stairway goes down the cliff to the sea below. It is located on the southern Oregon coast, and in the winter, the sea comes up to the bottom of the stairway.

This image was taken in mid-summer when there is about 50 yards between the end of the stairway and the high tide line.

The photo was made with an iPhone 6. The Photoshop Express Pinhole filter was used to convert the image to black & white.

Lonely Road

This rural road is located is a remote area of northern California. I often travel this type of road looking for interesting

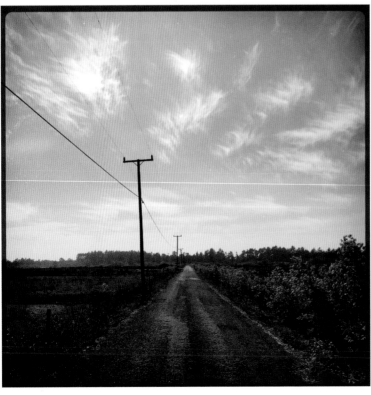

top. **New York City's 9/11 Memorial, under construction.**

bottom. **Church window, sans panes.**

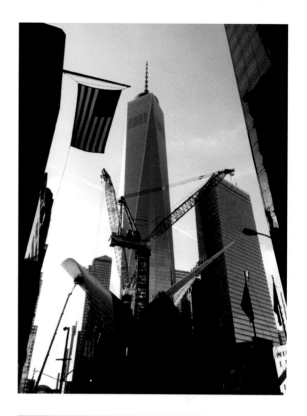

scenes and photo opportunities. On this day, the most appealing scene I found was the road ahead.

This image was captured with the iPhone 6 and processed with the Pro-Camera app and Grayscale filter.

9/11 Memorial

This image of the 9/11 Memorial was taken in 2014 during its construction. It was a haunting and sobering sight to view and photograph. The image was processed with the ProCamera app and the ILP 50 filter.

Church Window

This window, with a view to the sky, is part of a church under construction in Vina, CA, at the Abbey of New Clair-veaux. The window frame contains no glass.

The image was processed with the Hipstamatic app and Vintage filter to give the image an aged look.

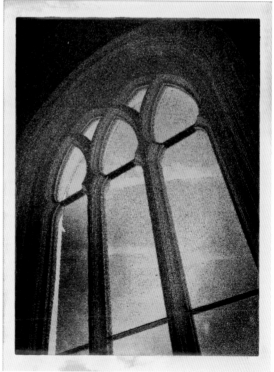

"Include strong angles and lines in your photographs."

Travel Iceland

Iceland is an island country. Located in the northern part of the world, it is known for its dramatic landscape of volcanoes, glaciers, and waterfalls.

Iceland is a prime location for black & white photography. In a country that is mostly void of color, black & white landscape photography presents opportunities in every area of this land. Water is also a significant part of the landscape, with numerous waterfalls in all parts of this island country. Steaming geysers and spectacular geographic features also award the black & white photographer with an endless array of subject material for using the iPhone.

The iPhone, with its many black & white apps, easily allows fantastic image of the landscape to be created. The images in this chapter provide viewing opportunities to see the landscape and possible subject matter for potential images if you decide to travel to this far-off country.

below. **Godafoss Falls, Iceland.**

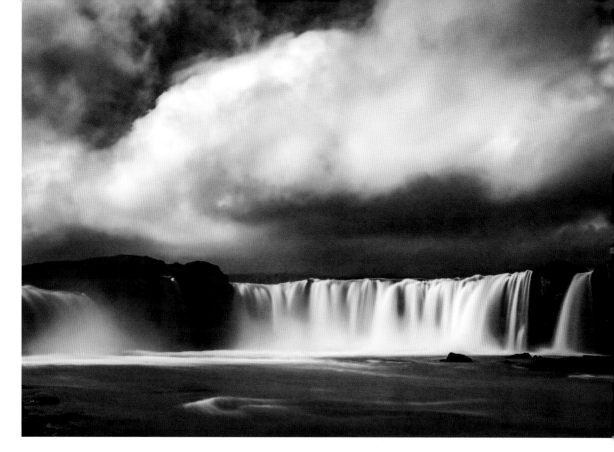

above. **A second view of Godafoss.**

Godafoss Falls

The images on this page spread show one of the many enthralling waterfalls located in Iceland. There are many vantage points from which to view Godafoss, but this one *(previous page)* allows the whole falls to be seen.

I took this image with the iPhone Live Photo using the Long Exposure filter, giving the water a flowing look. It was processed with the iPhone's Noir filter. Brightness and contrast were adjusted for added impact.

I captured a second image of Godafoss *(above)* from the trail leading to the bottom of the falls. This shows a portion of the falls, but the real attraction is the clouds overhead. The great variety of tones in the clouds and their grand size enhance the entire image.

I once again used Live Photo and the Long Exposure filter to enhance the water. The photo was processed using the iPhone's Noir filter.

"Compose the image with dramatic clouds in the sky for added appeal."

Diamond Beach

The name Diamond Beach refers to the many pieces of glacier ice that line the beach in this area. The ice comes in all sizes and shapes and is constantly changing as the tides move them in and out daily. The sand is black, which further enhances the white or clear ice.

I suggest photographing the ice from many angles to get a variety of views and lighting variations.

This image was processed with Photoshop Express. The Pinhole filter was used to darken the area around the ice and increase the brightness of the ice.

This allowed for maximum detail to be present in the photograph.

A second photo *(following page, top)* from Diamond Beach highlights a smaller ice formation glistening in the light like a diamond. In the background, a larger piece of ice is being washed by the tide.

When taking photos of the ice, look for pieces on the sand that are not moving with the tide. This will allow

"Play the odds and photograph the subject from multiple angles."

below. The jewel-like ice formations of Diamond Beach.

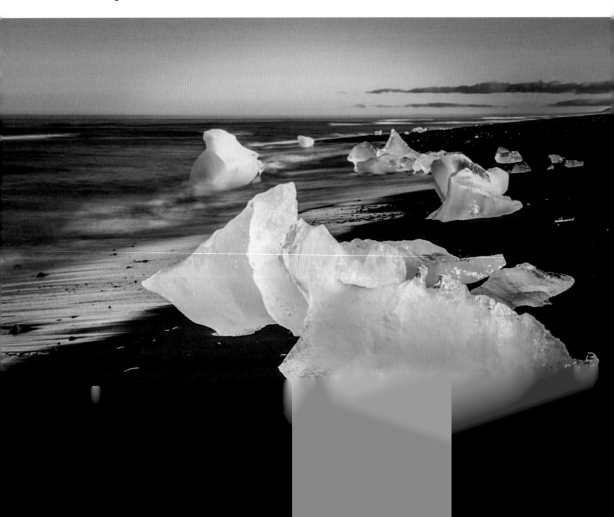

the photo to be produced more clearly and with better detail.

In this image, I included the moving water in the background to further enhance the whole photo. I used Live Photo, with the Long Exposure filter, to show the flow of the water.

Glacier Lagoon

When I took this image of the Jökulsárlón glacier lagoon, it contained hundreds of pieces of floating ice and offered multiple photo opportunities. I took this image because I was drawn to the stillness of the water, below the floating ice and the reflection of the ice in the water.

This image was processed with the iPhone's Noir filter.

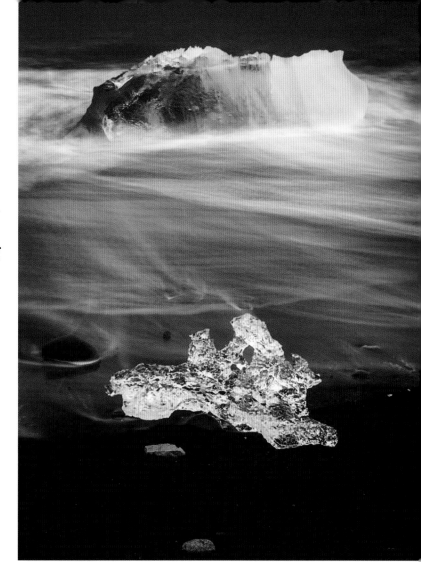

top. A detail shot from Diamond Beach.

bottom. Jökulsárlón glacier lagoon.

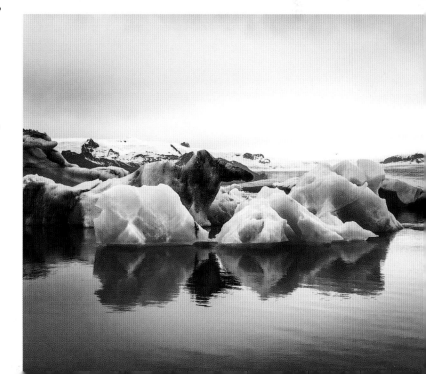

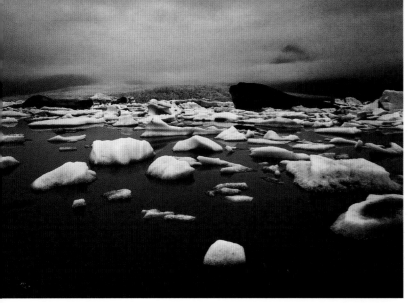

top. **Glacier lagoon with a dark, moody sky.**

bottom. **Iceland's Vestrahorn mountain range.**

very still, but the ice was moving out to the sea.

This photograph was processed with the iPhone's Mono filter.

Hofn

Sometimes you need to put all of the pieces together to get the photo you want. The grass on the black sand, the mountain range, and the wonderful clouds all came together to make this image a success.

Some of the questions that come to mind when composing a photo like this are: What is the most interesting part of the scene? What should be the subject of the photo? How much grass and sand should be included in the frame? Do the clouds add to or distract from the mountain in the background? When on location with your camera in hand,

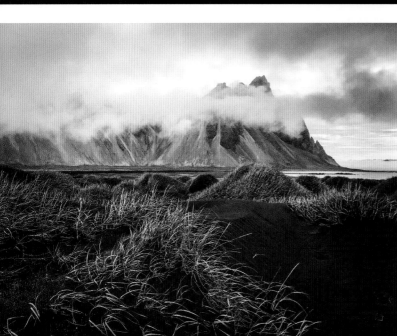

Glacier Lagoon & Clouds

Here is the Jökulsárlón glacier lagoon with a dark and cloudy sky. The water in this part of the lagoon was very dark, which made the white ice contrast more. In this area, the water was also

it is often difficult to answer these questions. That being said, I usually take many photos from lots of different angles and, when reviewing the shots later, choose the one that appeals to me most.

In this photo, the light tones of the grass lead the viewer's eyes up to the clouds and mountains in the background. The foreground contains dark sand and directs the viewer's eyes toward the center of the photo.

This image was processed with the iPhone's Mono filter. Brightness and contrast were adjusted to improve the tonal range of the image.

Gullfoss Close-Up

Gullfoss is one of the best-known and most widely visited waterfalls in Iceland. Located on the Golden Circle, it is a popular stop for tourists and photographers alike.

This image was taken from the trail leading up to the falls and shows a

right. **A close-up of the Gullfoss waterfall.**

small portion of the falls and some of the water spraying into the air. When at this falls, take photos from the overlook and then follow the walkway up to the falls. Getting close-up images give greater impact.

This image was captured with Live Photo and the Long Exposure filter. I used the iPhone's Mono filter for the black & white conversion.

"Look for powerful and dramatic scenes in nature."

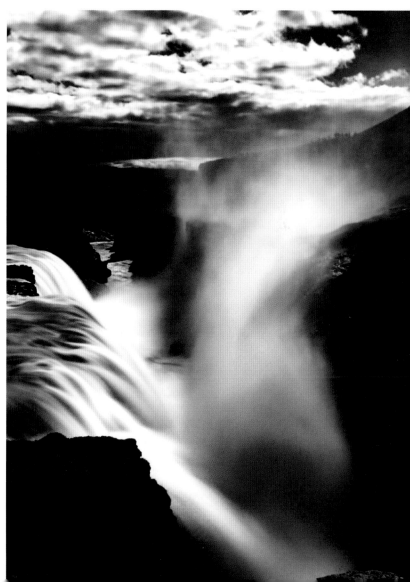

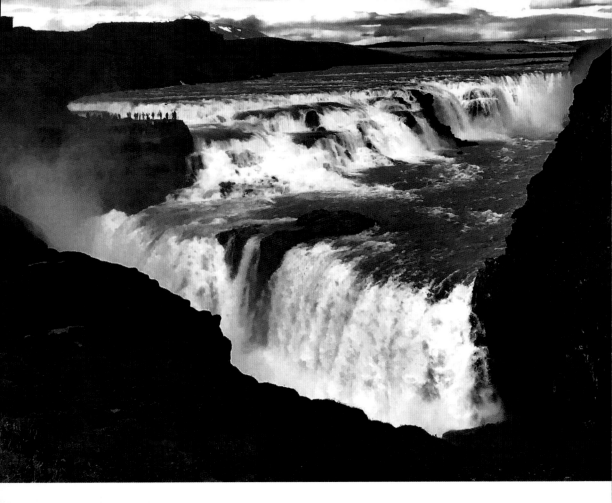

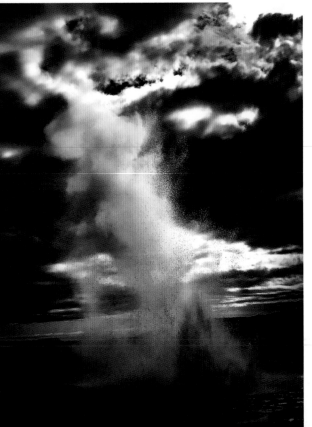

above. **Gullfoss waterfall.**

left. **Strokkur geyser.**

Gullfoss Waterfall

Here is a wider, more global photo of the magnificent Gullfoss waterfall, taken from an overlook point on the trail to the falls.

This image was made with an iPhone 7 and processed with the Camera+ app and the iPhone's Mono filter.

"Capture peak action when photographing moving subjects."

Strokkur Geyser

Strokkur geyser is located on the Golden Circle tour route. This wonderful but small geyser performs its show every 6 to 10 minutes. When I visited the location, I stayed for an hour and was able to witness numerous eruptions. The geyser eruption lasts several seconds; being ready to push the button when the spray starts is key.

I shot photos from several different sides of the geyser and searched for the best location against the clouded sky. In this photo, I used the backlighting from the break in the clouds to highlight the spray of the water and mist.

I processed this image using the iPhone's Noir filter.

Reynisdrangar

Reynisdrangar are basalt sea stacks located near the town of Vic in southern Iceland. This image was taken at quite a distance from of these magnificent subjects, but still shows their impressive size and shape.

I included the black-sand beach in the foreground to frame the bottom and hold the viewer's eyes at the center of the photo. The dark mountain on the right also directs the gaze to the center. The sky's scattered clouds provide a good background for the sea stacks.

The image with processed with Photoshop Express and the Pinhole filter, which darkened the edges of the image.

below. **Basalt sea stacks.**

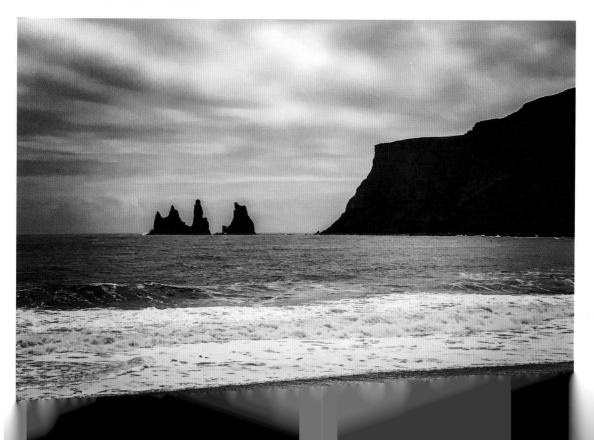

Hveravellir Nature Reserve

Hveravellir nature reserve is located in Iceland's highland area. This image shows a fumarole, or smoking rock pile, with smoke and steam coming from the earth below.

Using Live Photo and the Long Exposure filter allowed me to catch the smoke forming a trail in the direction of the wind flow. The sky in the background was of interest, as the light coming between the clouds added some depth to the image.

The image was converted to black & white with the iPhone's Mono filter.

Namafjall Geothermal Area

This fumarole in the Namafjall geothermal area was of interest to me due to the upward direction of the smoke and how it interplayed with the mountain behind it. I waited for the smoke to allow the peak of the mountain to show, giving additional interest and dimension to the image.

The photo was processed using Photoshop Express and the Noir filter.

"Wait for the clouds to part to capture dramatic light."

below. **Hveravellir nature reserve.**

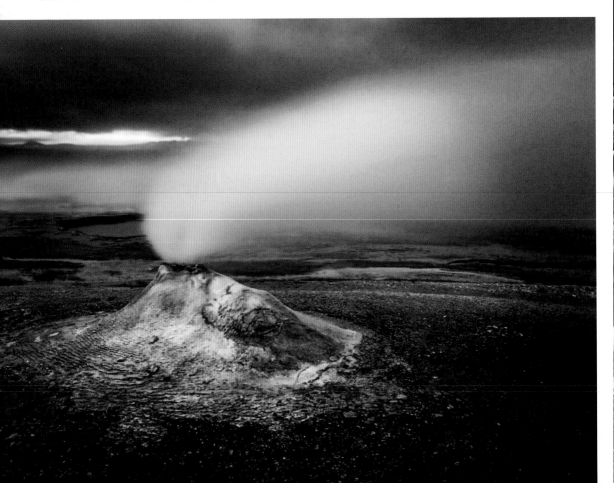

Mountain Range

Iceland has many wonderful mountain ranges that can be seen from the roads going in most directions. When traveling through this country, there are a multitude of opportunities to take photos from the road.

In this image, the main interest was the light coming through the clouds and the way it formed a silhouette of the mountain range. The key to good black & white images is always light, line, and shape. When taking images, look for those elements to make your photos more interesting.

This image was processed with the iPhone's black & white Mono filter.

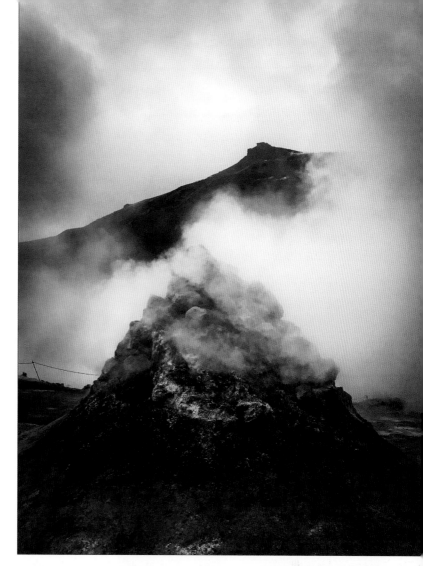

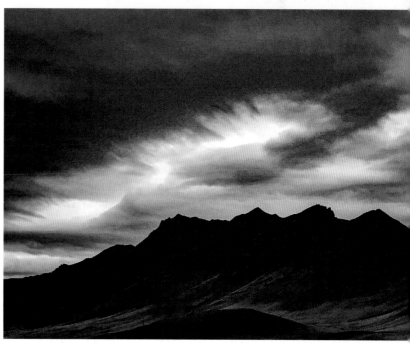

top. Namafjall geothermal area.

bottom. Icelandic mountain range.

River & Rocks

Iceland is home to numerous waterfalls. My interest at this location was the flow of the water created by the falls and the action on the surrounding rocks. The water was flowing at a rough-and-tumble pace as I stood on a rock with my iPhone. I took numerous images.

Most of the water and waterfalls in Iceland are created by the melting of glacier ice, and all travel to the sea.

I processed this image with the Tin-Type app to bring significance to the water coming from its source, an ancient glacier.

Old Building

This old building was located near Hofn in the southern part of the country. There are many old buildings located across Iceland, and some pose a challenge to get to. This building is a mile walk from the road. I thought it was of interest with its weathered wood and rough mountain landscape in the background.

I used a vertical format for this image to include the foreground road leading up to the building.

The image was processed using the iPhone Noir filter.

left. **A dramatic and lovely river-and-rocks composition.**
right. **A rustic, weathered building typical of the architecture of Iceland.**

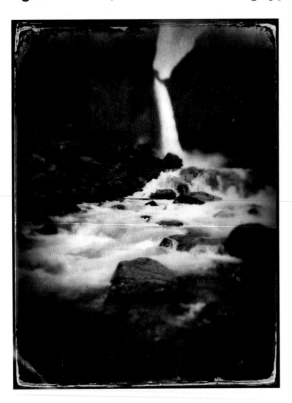 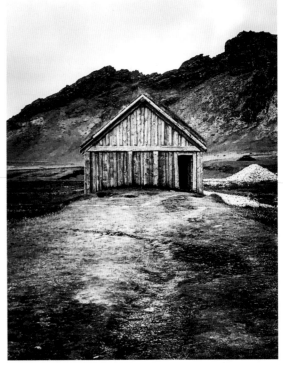

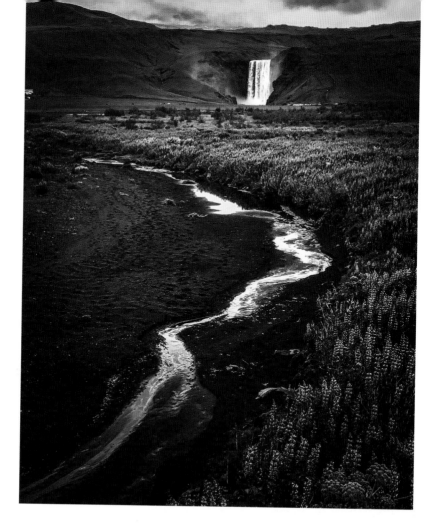

Skógafoss Waterfall

The Skógafoss waterfall is one of the largest and most popular falls in Iceland. Access to it is easy; it is located a short walk from the parking area.

There are many interesting angles to view the falls; it can be viewed up close or farther away, as in this photo.

Upon viewing the small stream of water that appeared to come from the falls, and was illuminated clearly by the sky, I felt it would be a perfect leading line to capture with an image.

The photo was processed with Photoshop Express and the Landscape filter. The contrast and brightness were adjusted to improve the tones of the image.

For those interested in color and flowers, those are blue lupines to the right of the stream. In color, the image was also dynamic.

"Seek out light and lines for good black & white images."

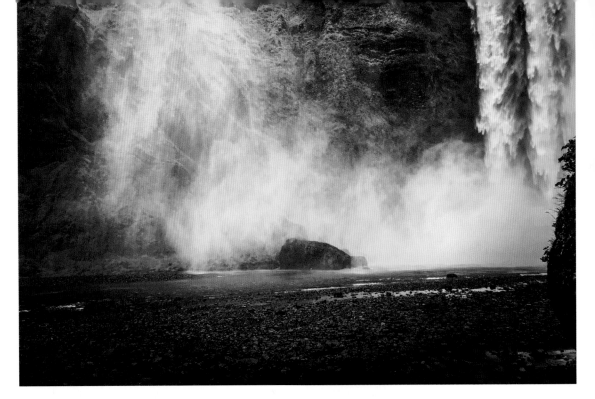

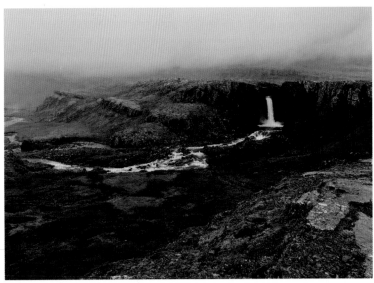

above. **Skógafoss waterfall from a close shooting distance.**

left. **Another of Iceland's waterfalls.**

Skógafoss Water Spray

Here is a close-up of the water spray coming off the Skógafoss waterfall. The large amount of spray that the falls continuously made caused the lens on my phone to became wet; this resulted in unclear images. Because of this, I had to wipe the lens with a soft cloth several times as I took images of the falls.

For this photo, I stood to the side of the falls, behind rocks and foliage,

as I needed protection from the fierce spray. I composed the image to include a small area of the waterfall on the right side of the frame.

Photoshop Express and the black & white Landscape filter were used to process the image.

Waterfall

It is no exaggeration to say that Iceland is covered with waterfalls. Here, the falls create a river below that will travel out to the sea. The land around the falls is black volcanic rock and is in sharp contrast to the white of the water cascading down its path. Low clouds in the top of the image added atmosphere to the sky.

"Keep your lens dry to avoid spots on your photos."

The photo was converted to black & white with the Camera+ app and the Noir filter. The brightness and contrast were adjusted to balance the tones.

Ruins

Old wood and pieces of buildings may be found on the ground in Iceland, a visual testament to man's attempt to shelter. The items add to the understanding of the cultural landscape and help us learn how people of the past may have lived in this northern land.

The image was processed using the Camera+ app with the Noir filter.

below. Icelandic ruins.

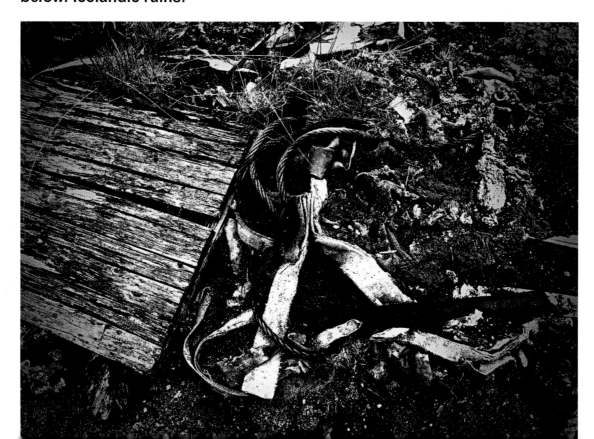

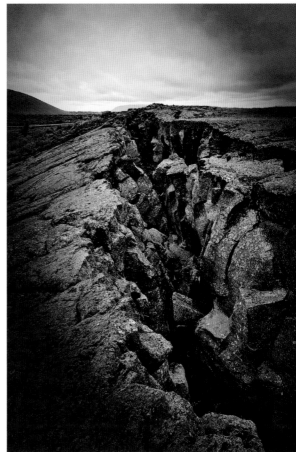

left and right. **Cracks in the earth caused by volcanic activity.**

Earth Cracks

There are many cracks in the earth in Iceland caused by volcanic activity or movement of the earth's plates. Some of these cracks are small, like the one in this photo *(left)*. Some are large and deep, with water running through portions of them. These cracks make for interesting landscape images against the clouded sky.

This photograph was processed using the ProCamera app and the 003 filter. The Dramatic Light app was used with the B&W 02 filter to complete the image.

A dramatic crack in the earth can be seen in this image of the Icelandic landscape *(right)*. The land appears to have lifted from beneath the earth and cracked open at the surface, exposing a large, craggy opening.

Black & white is the perfect medium to use when taking photos in Iceland, as there is little color to be seen on the barren landscape.

The Dramatic Light app was used to lighten the center of the opening and to darken the edges. This resulted in a more dramatic photograph.

Krafla Viti Crater

The magnificent Krafla Viti crater is filled with water and offers amazing photo opportunities from the established trail surrounding the top of the crater. Images can be taken successfully on all sides of the crater, depending on the light.

In the center of this photo there is a steam vent coming from the earth, producing a white cloud. Some of this steam is processed at a geothermal power station on the far side of the crater. This is a sight that should not be missed if exploring the crater.

The photograph was processed using the Hipstamatic app and Vintage filter to produce an antique look.

right. **The Krafla Viti crater offers fabulous photo opportunities.**

"Take advantage of dark skies and bright clouds for impactful, dramatic images."

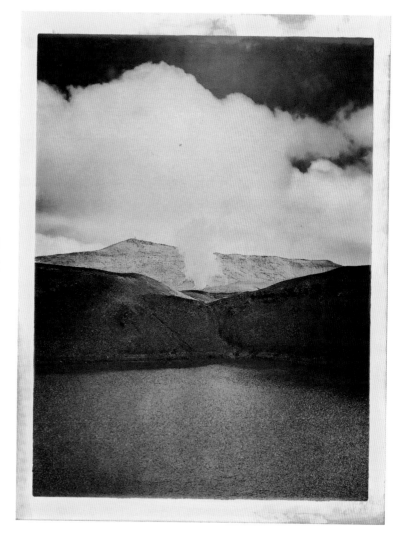

Nature

The nature landscape genre includes much of the world around us that has not been altered by man. Images of rocks, plants, water, and snow are all included in this chapter to illustrate examples and ideas of capturing the natural landscape in a photograph. The opportunities—from the large global image to the intimate detail of the close-up photo—are limitless and waiting to be visualized and recorded.

Take a hike, go for a walk, shoot some images, and immerse yourself in all of the beauty of the natural world.

Dogwood Flower

This white dogwood flower was one of thousands in a grove of trees. This image is not really a landscape, but a small part of one. It was included in this section to show how successfully the iPhone camera can take close-up images.

The photo was processed with the Hipstamatic app, Jane Lens, and Claunch 72 Film filter.

> ### *"Use your iPhone to capture artful close-up images."*

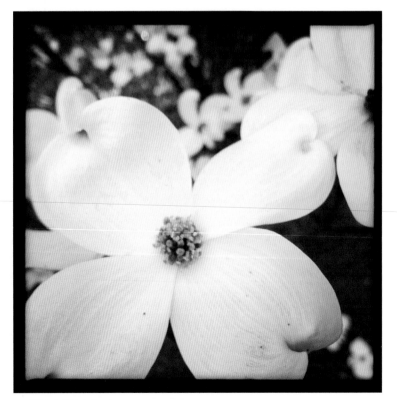

left. **A close-up of a dogwood flower.**

River & Snow

Water and snow are a good combination for landscape photos. For the best landscape snow photos, try to capture the photo soon after snowfall, when it is fresh and free of footprints and rests on the trees and foliage in a pristine condition.

When capturing this scene, I was attracted to the bend in the river and how it leads the eyes into the image.

The first image *(top)* was processed with Photoshop Express and the Pinhole filter. The edges were darkened to maximize the view of the water in the center of the photo.

A second variation *(bottom)* of the same river-and-snow scene was made with the TinType app. This app gives the image an old, antique look, which I find appealing. This app enables the user to vary the size of the blur effect around the image via the depth of field slider. The TinType app can be used for color or black & white and has additional sliders to create other interesting effects with an image.

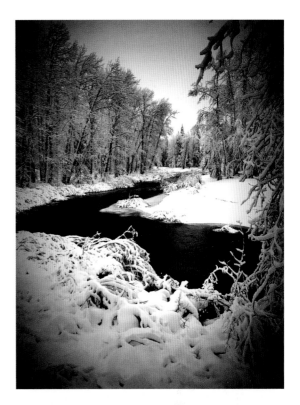

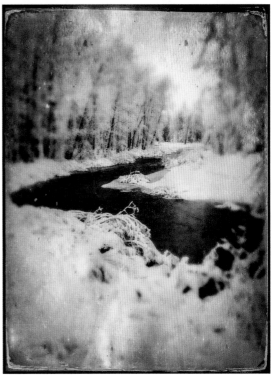

top and bottom. **Two variations of the same wintry scene.**

Lily Pads

Lily pads and flowers, with their nod to fairy tales and frogs, are fascinating to view. These water plants with thick and glossy leaves produce colorful flowers and serve as resting places for aquatic insects and amphibians.

The surface glow of the pads from the light above added a magical touch to this image, processed with the Pro-Camera app and the Tenderloin filter for black & white conversion.

"Make light and reflections the subject of some images."

Tree Reflection

This photo was taken in the Sierra Mountains at sunrise. Early light silhouetted the trees on the right. The attraction of this photo was the reflection of the trees on the smooth river surface.

Light, lines, and texture are key to successful black & white landscape photos. Look for these elements when making landscape images.

This photograph was processed using the iPhone software and the Noir filter.

Fern Close-Up

The fern image was taken in the Redwood Forest of northern California.

below. The light and reflections in this pond make this a compelling image.

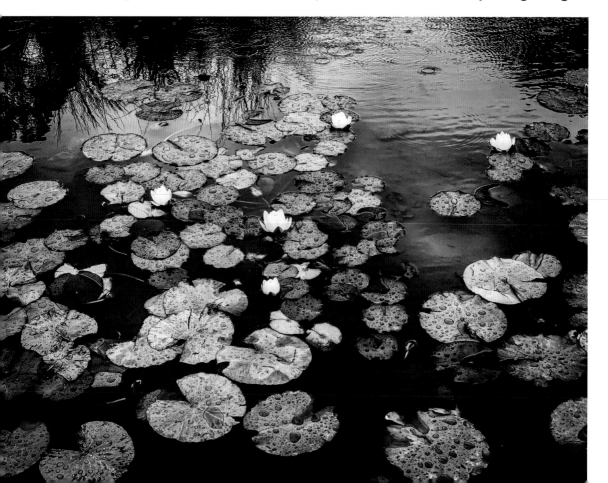

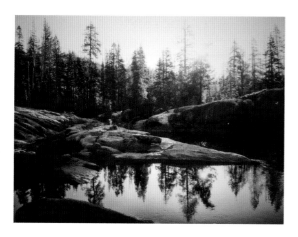

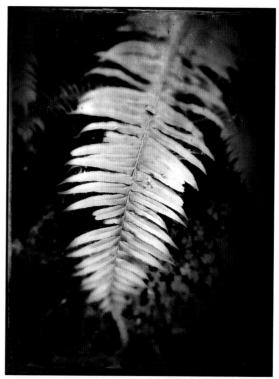

Two iPhone apps were used to create this photo. The image was first processed with the Dramatic Black & White app to add lightness in the center of the photo and darkness on the sides. Next, I used the TinType app to add a vintage texture and frame on the image for a more interesting look.

Starfish

This starfish (a.k.a. sea star), was lying on the sand under a rock at low tide on the northern California coast. Starfish are very common in the area and can often be found in tide pools during low tides. Starfish are not really a fish, but an echinoderm; they are related to sea urchins and sand dollars.

This image was processed using the ProCamera app and the 025 filter. Camera+ was used to apply the Dark Grit frame.

top left. **Sunrise in the Sierra Mountains.**

top right. **A close-up of the beautiful detail in a fern frond.**

bottom. **A starfish gets the star treatment in this image.**

Morning Sky

Sunrise and sunset photos are often more interesting and dramatic in color, but incorporating essential elements into your black & white photo can lead to a strong sunrise or sunset image.

In this image, captured in the Sierra foothills, I combined a spectacular cloud-filled sky with a prominent tree silhouetted against the sky. The canyon filled with fog in the lower part of the photo catches the morning light.

The Photoshop Express Pinhole filter was used to darken the edges of the image.

Rocks & River

The river is the subject of this image, but the rocks on its banks give

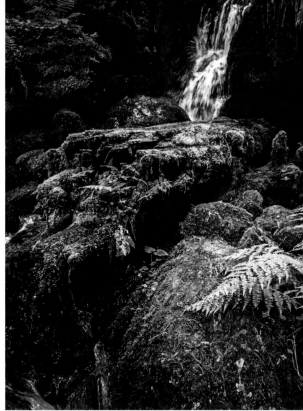

left. Light-toned ferns stand out against a dark tree trunk.

right. The light-toned waterfall leads the eye to the foreground subjects.

the photo its real interest. When taking images, scan for interesting items to frame and complement the look and tones of the image. The large rocks in lower part of this image draw attention and lead the eye to the river in the background.

This image was processed with the iPhone's Mono filter.

Ferns, Redwood Forest

When photographing ferns in the forest, the area behind them should be darker, allowing the plants to stand out. In this image, a dark tree trunk was used to provide the contrast.

Another important factor is movement: If you want the ferns to be in focus, look for a location without wind. If the ferns are resting against a tree or log, movement will be lessened.

The Camera+ app was used with the Mono filter. Brightness and contrast were adjusted to retain detail in the fronds and darken the tree trunk.

Waterfall & Fern

This image was taken on the northern California coast in an area of lush vegetation. The small falls in the rear leads to the rocks and ferns in the front right.

This image was taken with an iPhone 6 and converted to black & white using the Photoshop Express Pinhole filter.

"Use slow and fast shutter speeds for waterfall photos."

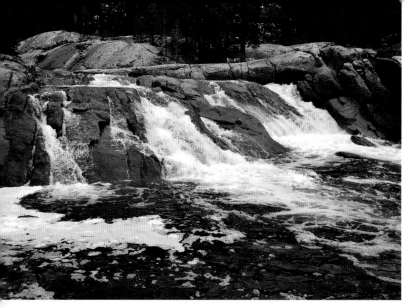

top. **Multiple waterfalls and great contrast make this image sing.**

bottom. **California's Pacific Flyway.**

bubbles in the river below. The faster the shutter speed, the greater the stop-action capability of the camera.

The image was converted to black & white using the Snapseed's Fine Art filter. A vignette was applied to darken the edges of the photo.

Birds in Flight

California's Central Valley is known as the Pacific Flyway. At times, it is home to tens of thousands of birds flying from Canada to points south.

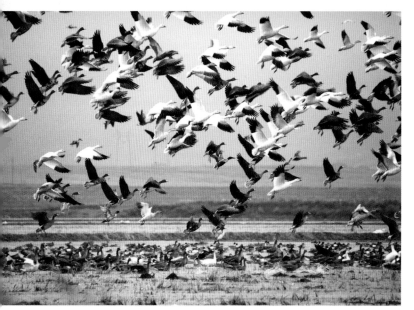

Three Falls

Rivers and waterfalls in California's Sierra Mountains are fed water from melting snows. These falls are at an elevation of about 7000 feet, and the water is icy cold and crystal clear.

The image was made with an iPhone 7. A shutter speed of $1/389$ second froze the water flowing over the rocks and

When taking this type of image, stealth is necessary. The birds are attuned to movement and may fly off before you get the photo.

The image was converted to black & white using the Camera+ app and the Mono filter. The brightness and contrast were adjusted to enhance the image.

Two Leaves

When seen in color, the two leaves in the lower portion of the frame are bright yellow, and they make a dramatic statement when shown against the dark granite rock in the background. The leaves had fallen from the tree behind it and were laying on the rock, eliminating the worry of movement and a blurry exposure.

The TinType app was used to enhance the look and feel of this classic image and soften the edges, further defining the shape of the leaves.

Forest Floor

A dark and moist forest floor is often filled with ferns and other low-lying vegetation throughout the year. I was drawn to this scene due to the denseness of the greenery and the

variety of plants presenting in varying shades of green.

The image was processed using the Camera+ app, and a dark vignette was applied to the outer edges of the image.

"Artfully arrange small landscape elements for a better composition."

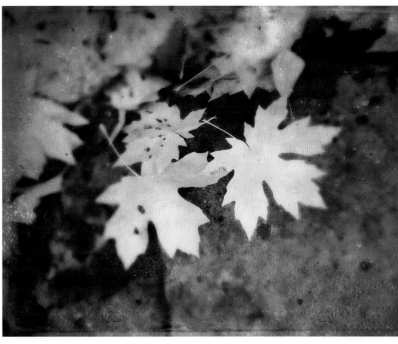

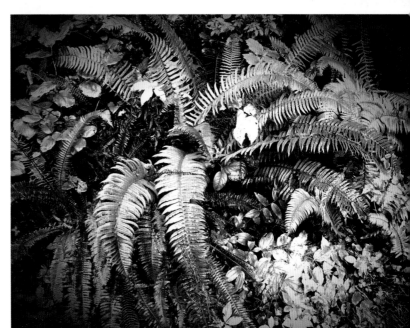

top. The TinType app was used to create an image of fallen leaves with vintage appeal.

bottom. The forest floor is rich with textural foliage in contrasting tones.

Winter Lake

The Sierra Mountains contain many small lakes and ponds that are fed by natural springs and snow melt. This lake was photographed during the early spring and contains ice and snow on a side that is hidden from the sun. The snow is gone from the trees that are reflecting in the lake below. During the winter, this area may contain up to 12 feet or more of snow, and it becomes difficult to hike the trails without skis or snowshoes. These small lakes are the beautiful gems of the Sierras.

This image was converted to black & white using the ProCamera app with the APX 100 filter. A vignette was used to darken the edges of the image and highlight the center snow and rocks.

Cows in Field

While driving the backroads of coastal northern California, farm scenes are a common sight and make for interesting photo opportunities. Landscapes, from common to fascinating, present shapes, sizes, and subject matter wherever you may be. Open your eyes to envision new ways to record the landscape and take photographs that capture your imagination.

This image was made early in the morning with the coastal fog hanging in the field. I found these animals to be as interested in me as I was in them.

I captured this photo from the side of the road using my iPhone 7. The file was converted to black & white using the ProCamera app and the Street KTR1X filter.

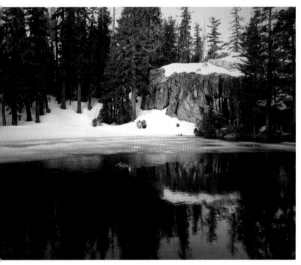

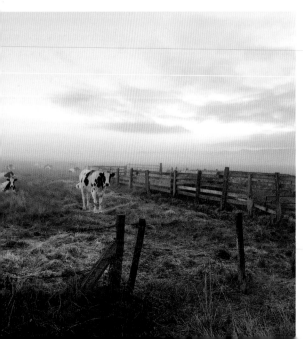

top. **A winter lake in the Sierra Mountains.**

bottom. **Cows in the field in northern California.**

top. Donner Lake in California.

bottom. Water, sand, and trees take on an abstract look.

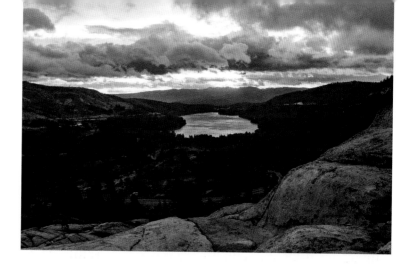

Donner Lake

Donner Lake in California was strikingly beautiful, glowing and reflecting the clouds above on this early-fall morning in the Sierra Mountains. The rising sun can be seen coming over the mountains in the center background, and it illuminated the clouds hanging in the sky.

This photo was taken with an iPhone 5 and converted to black & white using Photoshop Express with the Landscape filter. The Clarity and Dehaze filters were also used to improve the contrast of the lake and clouds.

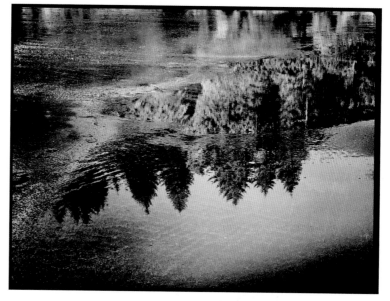

Tide Pool Reflections

The tide was low on this day, and many pools of water in the sand were created as a result. I found the trees from a hillside in the background reflecting in the pools of water. It created an abstract image of water, sand, and trees.

The photo was processed with the Hipstamatic app and Jane Lens with the Rock BW-11 Film filter. The Camera+ app was used to adjust the brightness and contrast of the image.

"Capture landscapes with a variety of looks."

top and bottom. **Water has many moods, and variations in light, current, and other factors can result in very different looks in your images.**

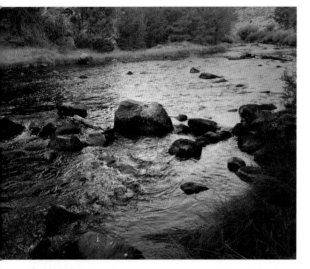

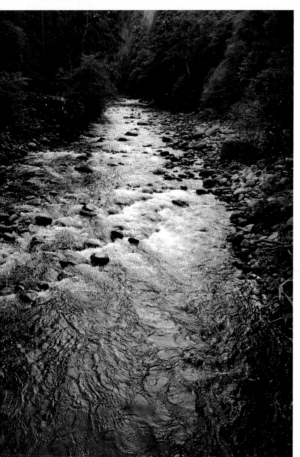

Flowing Water

This photo was taken in the Sierra Mountains. The water was running fast and clear. I chose to show the water as clearly as possible to give it a realistic look. The rocks in the image are the intended subject of this photo and are positioned to draw the eye first.

This image was processed using the Camera+ app and the Mono filter. A dark vignette was placed on the outer edges of the image, and the brightness and contrast were adjusted to improve the overall look of the photograph.

Sense of Calm

This river is calming to the eye as it gently flows through a canyon of trees. Rocks line the borders and cross the river to disrupt the evenness of the flow and create movement on the surface. The light shining from above evenly illuminates the surface of the water and shows the patterns of flow.

This image was processed using the iPhone camera's Noir filter. The brightness and contrast were adjusted to further highlight the water and darken the trees.

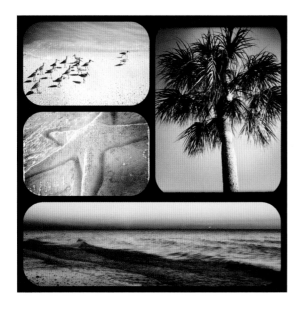

Florida Collage

Combine several images in one frame to create a wonderful montage to share on social media. These shots were taken during a Florida vacation and show four distinct looks of the local scenery.

The PicPlayPost app was used to create the collage. This fun app offers several options for the number of images you include in the collage and the color, shape, and design of the frame. I try to keep the number of images in the collage to a minimum so each one is large enough to be clearly seen.

After creating the montage, I converted the image to black & white using the Camera+ app and the Mono filter.

"Group related images for visual impact and a storytelling feel."

left. **A collection of related images.**

right. **A yucca plant photographed in Balboa Park in San Diego, CA.**

Yucca Plant

Yuccas are a great subject for a dramatic black & white photo. This image contains dramatic lighting and strong lines—essential ingredients for a powerful black & white shot. The photo was taken on a clear afternoon with strong directional lighting, resulting in high contrast that further defined the plant's strong visual lines and shapes.

The photo was converted to black & white using the Snapseed app and the Faded Glow filter.

Trees

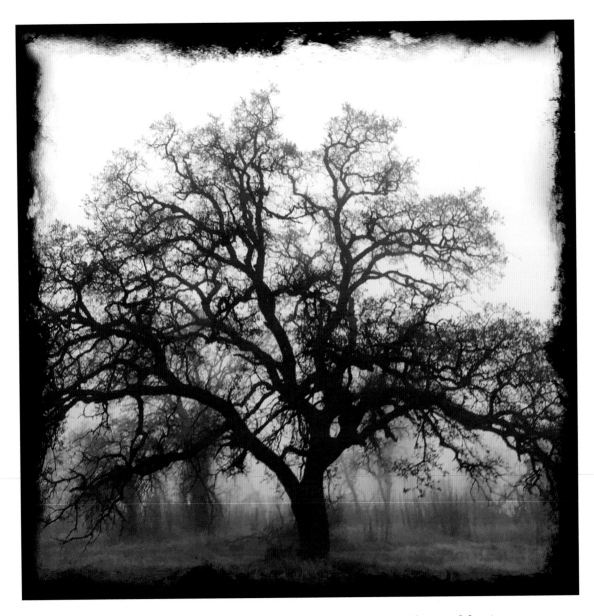

above. **This fog-enshrouded tree makes for an evocative subject.**

following page. **A grove of yellow aspens looks striking in black & white.**

Trees have always been a favorite subject of landscape photographers. Whether covered in leaves in summer or in winter, trees present excellent opportunities to photograph both in color and when presented in black & white.

In some regions of the country, redwoods grow hundreds of feet tall. Other types of trees line the coastal water of our Pacific borders. Whether in urban settings or rural scenes, seek out subjects with character for excellent photographs. Use the iPhone to take some tree photos today.

Foothill Tree in Fog

Photographing trees in a black & white format may be most successful when leaves have fallen and bare limbs expose the true shape, size, and structure. This mighty oak tree has a tremendous array of limbs and branches creating a perfect shape. Taken on a foggy morning, this photo has a chilling and dramatic ambiance.

The Camera+ app with the Mono filter was used to convert this image to black & white with a Dark Grit frame added to produce an artistic look.

Fall Trees

This grove of yellow aspen trees was photographed in the Sierra Mountains with an iPhone 5 camera. The leaves on aspens turn a spectacular yellow in the fall and contrast beautifully against the dark-green pine forest.

The TinType app was used to produce a more abstract and artistic look to the image. The depth of field slider was adjusted to allow the trees intended to be the focal point to better stand out in the final image. The Camera+ app was used to brighten the "yellow" trees and darken the surrounding dark "green" trees.

"Use a shallow depth of field to emphasize the main subject."

top. **An early-morning capture made on a snowy mountaintop.**

bottom. **This grouping of trees, with their similar shapes, called to me.**

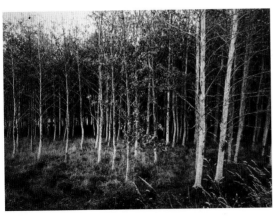

Mountaintop Trees

This early-morning image of trees on a snow-covered mountaintop was taken after a night of snowfall and shows the limbs drooping due to the weight of the fresh snow. Although this image was taken on a Sierra mountain, similar-looking images of trees draped in winter snow may be taken in many areas of the country during the winter season.

This image was processed using the ProCamera app with the Hard Gray filter. A vignette was placed on the edges to darken the sky and snow. The Camera+ app was used to add a thick black matt to accent the dark tones of the trees and contrast of the white snow.

Tree Grove

I found this grove of trees while traveling on the back roads of southern Oregon. These trees were of interest with their similar-sized trunks and white bark. The soft light on the front of the grove added to their look.

The photo was captured with an iPhone 6. The ProCamera app and Tenderloin filter were used to convert the image from color to black & white.

"The most successful snowy landscape images are made soon after snowfall."

Seaside Palms

I viewed these two trees and the white clouds overhead while on a morning walk in Miami, FL, and knew I could make a remarkable image of the Florida coast.

The Hipstamatic app and Jane Lens were used to create a square format and white border. ProCamera was then used with the 003 filter to convert the image to black & white. The brightness and contrast were adjusted to enhance the tones.

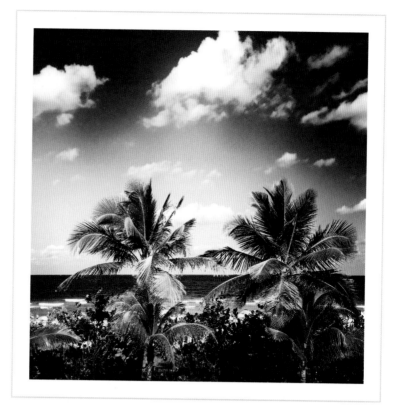

Treetop

A leafless deciduous tree against the sky presented great abstract patterns, and the blue sky was a good background to display the varied limbs.

The file was converted to black & white with the Camera+ app and Ansel filter. Snapseed's Black Frame #23 was used to add the border.

top. **Palm trees located in Miami Beach, FL.**

bottom. **Leafless branches filled this photograph with beautiful abstract patterns.**

Redwood Tree Bark

When taking photos of redwood trees, look for angles and positions to show the tree size and height. This image was shot from a low angle, and therefore, the glorious height of these trees is evident as they stretch to the top of the frame.

The photo was processed using the Camera+ app. I used the Antique filter to add a brown tone to the photograph and applied an Old-Timey frame to further enhance the vintage look of the image.

Treetops in Fog

Coastal fog lingered in the forest on the morning I went hiking and photographed these big trees.

The most common view of the trees, eye level, allows study of the tree trunks and their massive size. This photo was taken looking up to the treetops and shows the fog and light interacting with the uppermost branches. Standing very close to one large tree, I used it to create a strong leading line to the photograph's center.

The file was processed with the Pro-Camera app and 003 filter.

left. **A low camera angle emphasized the height of this tree.**

right. **Coastal fog added a sense of mystery in this image made in California's Redwood National and State Park.**

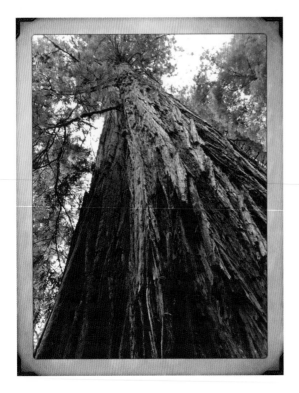
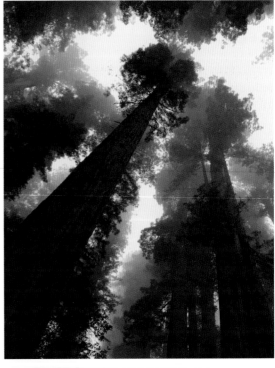

Forest of Trees in Fog

On this frosty winter day, the fog hung low to the ground. I was out for a hike with my camera and noticed these trees silhouetted by the light and fog in the background. I composed the image with one prominent tree in the foreground. It was the kingpin to the grove behind, and from this viewpoint, all the trees were separated by the light around them.

This photo was processed with the Hipstamatic app and the Lucifer VI Lens. BW-11 Film was used to convert the image to black & white.

Lake at Donner Summit

This image was taken in the Sierra Mountains after an early-autumn snow. The part of this scene I found most appealing was the log resting in the lake and covered in fresh snow. The log leads the viewer's eyes into the scene, showcasing the line of trees and their reflections on the lake. The snow in the lower left of the image acts as a border. The dark tones of the lake create a dynamic contrast to the white and imparts a sense of depth in the photograph.

The image was converted to black & white using the ProCamera app and the 001 filter.

"Take advantage of strong backlighting to create effective silhouette images."

Trees & Sea

Trees can form interesting and dramatic patterns and assist in framing your image. On this day, I was taking photos of the sea behind the trees but changed my theme upon viewing the interesting pattern of these tall trees. The soft light coming from behind the trees added an aura of mystery.

Cropping this image in the square format allowed further use the trees as the border and frame.

This photo was processed with the Hipstamatic app and the Jane Lens. I used the Claunch 72 Monochrome Film filter to convert the image to a warm-toned black & white.

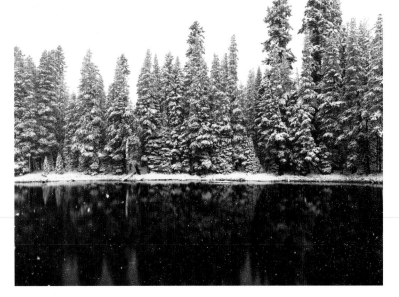

top. The warm tones in this image create an aura of mystery.

bottom. Falling snow in the Sierra Mountains.

"Use natural elements to frame the star subject in your images."

Reflections

This image was taken in the Sierra Mountains during one of the first snows of the season. The lake was not frozen, so its hard, dark tone made for good contrast for the falling snow. The treetops in the image are the subject. I love the coating of snow on every limb.

The photo was processed with the iPhone Noir filter, and the contrast and brightness were adjusted to improve the tones of the image.

Trees & Sky

Showcasing the leafless branches of a tree against a light sky can make for a beautiful image. Here, the early-morning light behind the tree allowed for a beautiful silhoutte. The trees on the left form a border and lean toward the right, drawing the eye to the more prominent trees on the opposite side of the frame.

The image processing was done with the iPhone's Noir filter.

Single Tree & Frame

This single tree was photographed in Shasta State Historical Park near Redding, CA. The sky behind the tree was dark blue, creating a silhouette image when converted to black & white. The tree was very tall, so I shot from an angle to capture its top.

The file was converted to black & white with Camera+ and the Silvertone filter. A Light Grit frame was applied to finish the image.

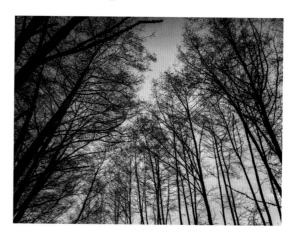

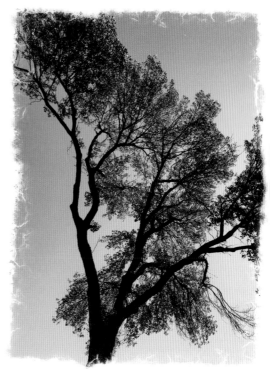

top. Treetops in the beautiful Sierra Mountains.

bottom. A dramatic frame suits this equally dramatic subject.

Tree & Sea

The subject of this photo is a single tree placed prominently in the center of the image. However, the photo features more than just a tree: it also includes the waves breaking on the rocks and the sea behind the tree. The sky adds to the ambiance of the image, with the morning light breaking through the clouds.

The iPhone's Noir filter was used to process this image.

Vintage Appeal

The trees in this landscape are not big or dramatic, but they were unique to me, so out came my camera.

I used the TinType app to add blurry edges and "print defects."

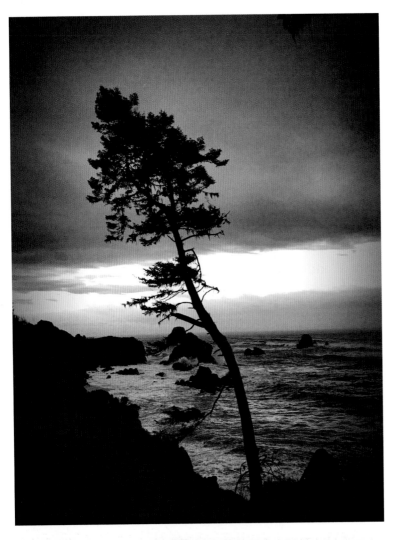

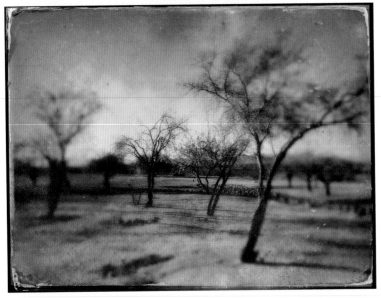

top. **This single tree makes a big statement.**

bottom. **The TinType app lends a vintage charm to this image.**

Single Palm Tree

This image was taken near the water in South Beach, FL. I saw the early-morning light striking the side of the tree, giving it shape and form, and knew I had to photograph it.

I chose a square format for the image to further isolate the tree and give its shape greater impact.

The image was processed with the Hipstamatic app. Warm tones were added to enhance the mood.

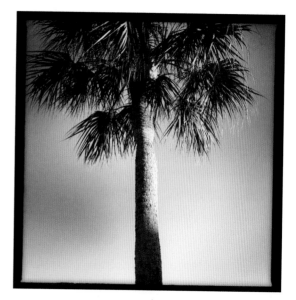

One Tree

This tree was photographed in northern California, not far from the coastal shore. Not many single trees stand in this area due to the winter winds that blow through and damage trees that stand without natural protection. The style of this image is minimalist with a single lone subject in the frame.

This photo was processed using the Camera+ app and the iPhone's Noir filter. A vignette was applied to darken the sky and foreground and create a circle of light behind the tree.

"Consider centering a strong single subject in the frame."

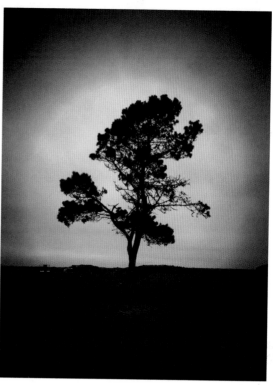

top. **A South Beach, FL, palm tree.**

bottom. **This resilient tree was a photo-worthy subject.**

Lone Tree in Fog

Many elements are contained in this image, taken in the Sierra foothills. To the left of the tree is a road, and to the right is a fence that gives the tree a reference point in the landscape. The small puddle in the foreground is illuminated by the light bouncing off the fog. The trees in the background add depth to the image. The primary subject, the large, barren tree, stands against the light of the morning fog.

Photoshop Express and the Pinhole filter were used to darken the edges of the image and highlight the center fog.

"Look for solitary items as subjects for photos."

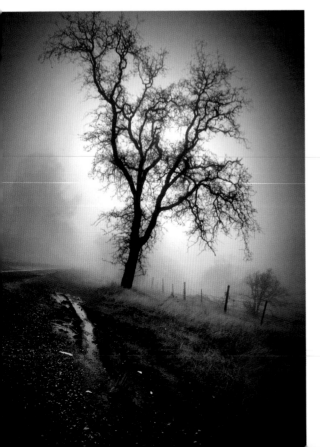

Looking Up

Looking up to the sky in the Redwood Forest provides a unique perspective that emphasizes the size and shape of the massive, aged trees. The light from the sky silhouettes the shape of the trees, creating a circle of light. This high-contrast photograph presents an abstract look at nature and is an example of the creative work that can be done with the iPhone camera.

The image was processed with the Photoshop Express Pinhole filter to darken the edges of the image. The contrast and brightness were adjusted to create the overall high-contrast look of the photo.

Redwood Forest

Light is one of the most important elements in black & white photography. When taking photos in the Redwoods,

left. **Though the tree is the main subject, various elements contribute to the strength of this image.**

right. **An artful approach to a cluster of magnificent Redwoods.**

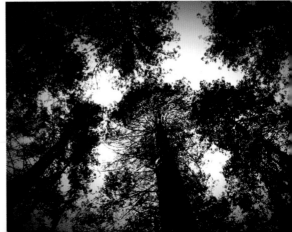

look for scenes with soft light in the background that will draw the viewer's eyes into the scene and allow details in the center part of the image to become visually accessible. The ferns in this image create a soft, appealing ground cover and transform the area into an inviting location to stop and take a photo.

The image was processed with the Hipstamatic app, Jane Lens, and Claunch 72 Monochrome Film filter.

Truckee River

The trees in the background create a frame for this image, taken in the Sierra mountains. The attraction of the photo is the curve of the water and the sky reflected in it.

The ProCamera app was used to convert the image to black & white. A vignette was added to darken the edges of the image and highlight the water.

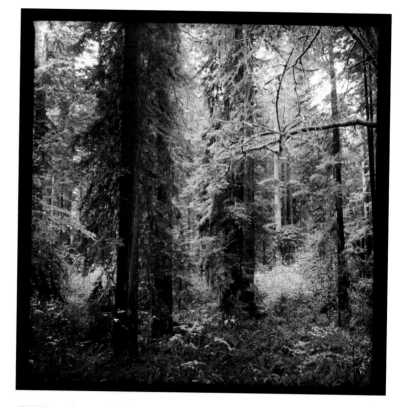

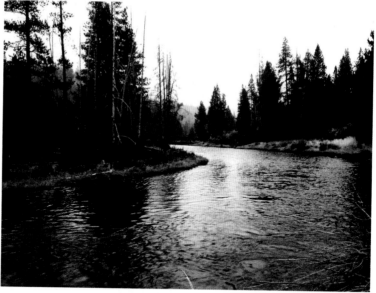

top. Soft light produced an inviting, dreamy rendition of these trees.

bottom. A vignette darkened the edges of the image and highlighted the central reflections.

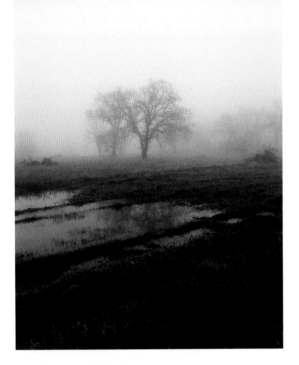

Down in the Valley

This image was taken after climbing up a hillside in northern California's Sierra foothills. Fog can add atmosphere in an image and lend a mysterious feel that lends itself to an extraordinary work of art. These two trees were of interest to me, as was their reflection in the standing water in the foreground. This aspect of the photo created a sense of greater depth in the image and leads the viewer's gaze to the trees in the background.

The image was converted to black & white using the Camera+ app and the Noir filter. The brightness and contrast were increased to darken the foreground and make the sky lighter.

Redwood Trees & Path

These two large redwoods epitomize the strength and beauty of the century-old monuments in this spectacular forest. What makes this image interesting, besides the size of the trees, is the trail between them that leads deeper into the forest.

The image was converted to black & white using Photoshop Express and the Green filter. Use of this filter lightened the ferns and made the entire image brighter.

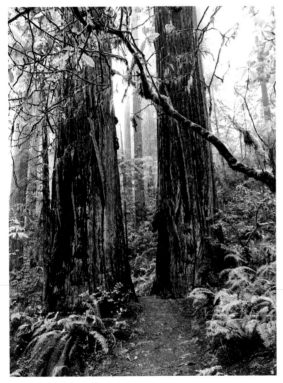

top. **The reflections of the trees and the atmospheric conditions appealed to me in this situation.**

bottom. **Two century-old redwoods.**

Key West Palms

This image was taken at sunrise, as the sun illuminated the sky and clouds over the sea. The strength of this image comes from the many trees and the variety of shapes. Also of interest are the hammocks, which provide an inviting place for visitors to relax and enjoy the tropical breeze.

The iPhone Noir filter was used to convert the image from color to black & white. The contrast was increased, creating a silhouette of the trees against the sky and sea.

Cactus

Well, a cactus is not a tree, but I wanted to include this image in this chapter. Stark and tall, with its limbs extending to the sky, this saguaro cactus is a beauty. This image was taken with strong backlighting that highlighted the subject's shape and showed off its many sharp needles.

The homes and other buildings in the frame create a sense of place. The telephone pole on the left was included to underscore the shape and size of the cactus. It is a fitting companion.

"Capture some images in a vertical format to add variety to your portfolio."

The image was converted to black & with the Dramatic Black & White app. The contrast was adjusted to amp up the silhouette effect.

top. **Palms and hammocks.**

bottom. **A cactus: a subject with great form and texture.**

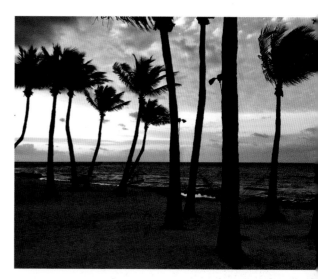

Index

AmherstMedia.com

Create Pro Quality Images with our iPhone Photography for Everybody Series

--THAT WITH A *TWIST* OF TREE LIMB THE HILL-SIDE ITSELF WILL GAPE WIDE--

--REMAIN OPEN FOR *TEN* SECONDS BEFORE IT AUTOMATICALLY CLOSES AND BECOMES WHAT IS EXPECTED, AND THEREFORE SAFE--

--AND *CONCEALS* THE FOX'S DEN FROM *PREDATORY* EYES.

HORSE AND RIDER PART--

--IN SMOOTH, SURE-FOOTED RUNNING DISMOUNT--

--EACH IN CONCERTED CONJUNCTION WITH THE OTHER'S MOVEMENTS.

THEY'VE PRACTICED IT IN SECLUDED HILLS ON COUNTLESS SUNNY AFTERNOONS.

YES, TORNADO, YOU'VE EARNED A GOOD MEAL.

THE BEST IN GRAIN AND OATS IS COMING UP PRONTO, I PROMISE.

I HAD HOPED BERNARDO WOULD BE HERE TO MEET US--

--BUT HE MUST HAVE FELT IT WISE TO STAY AT THE HACIENDA IN CASE MY FATHER CAME KNOCKING AT MY BEDCHAMBER DOOR FOR SOME UNEXPECTED REASON.

I DON'T KNOW WHAT HE WOULD TELL MY FATHER THAT WOULD ADEQUATELY EXPLAIN MY ABSENCE--

--YET IT NEVER CEASES TO AMAZE ME, EVEN WITHOUT A VOICE HE MANAGES TO COMMUNICATE A TALE SO CONVINCING--

--EVEN I BEGIN TO BELIEVE IT.

KNOWING BERNARDO, HE'LL PROBABLY INTIMATE TO MY FATHER THAT I HAD A RENDEZVOUS WITH A SEÑORITA.

THAT MY FATHER WOULD WANT TO BELIEVE--

--ALTHOUGH I SUSPECT IF I HAD BEEN A DAUGHTER--

--AND SUCH CAME TO HIS ATTENTION, HE'D BE FIT TO BE TIED.

THERE HADN'T BEEN ANY *CIRCULAR STAIRCASE* MADE OUT OF STONE STEPS. HE AND BERNARDO WORKED ON THE PROJECT OVER THE COURSE OF A YEAR.

THEY'D ORIGINALLY THOUGHT IT WOULD TAKE THEM A COUPLE OF MONTHS TO COMPLETE. A TOUGHER JOB THAN THEY'D FIGURED.

THEY HAD OTHER DUTIES TO OCCUPY THEIR TIME, SUCH AS SETTING UP THE LABORATORY WHERE HE COULD TINKER WITH NEW GADGETS AND TRY TO MAKE THEM WORK BEYOND THEORY.

ZORRO'S DRESSING QUARTERS REPLETE WITH RESERVE OUTFITS AND ADEQUATE METAL BRACES TO HOLD SWORDS AND WHIPS STAND AT THE TOPMOST TIER.

HE LOVED TO DABBLE IN SCIENCE. HE ADMIRED *GALILEO* AND *LEONARDO DA VINCI.* THE DESIGN OF THE CAVE DOOR WAS INSPIRED BY HIS EXPOSURE TO THEIR GENIUS.

IT IS TIME TO LEARN WHAT HAS BEEN HAPPENING IN DON DIEGO'S WORLD WHILE ZORRO HAS BEEN ON THE PROWL.

Time to shed his cloak, as if losing billowing wings.

There were occasions he chose not to wear it, for there were times when the cloak could be cumbersome.

He had to make sure its folds stayed clear of his arms during sword duels against multiple foes.

But the swirling dark blue was effective at disguising body shape and aided him in merging with shadows.

Bernardo always kept the wash basin filled with clean water for his return, and bars of soap were always placed nearby.

His father would look askance and ask too many questions if he saw his son with a grimy face, sweat-dried dirt clinging to his flesh as if he had been working—

—and not "doodling" with pen and ink on silly pictures, and writing "little dialogues" of questionable merit.

KEEP THE SCENTED HANDKERCHIEFS AVAILABLE.

HE COULD FLUTTER A PERFUMED HANKIE WITH AS MUCH EASE AS HE COULD PARRY AN EPÉE.

BECOME THE EFFEMINATE PERSONNA HE HAD CREATED FOR HIMSELF.

DON THE COLORFULLY EMBROIDERED LEGGINGS OF SHEEPSKIN; THE MATCHING VEST; THE EUROPEAN RUFFLED SHIRT.

HE RATHER LIKED THE WAY HE LOOKED IN THE CLOTHES--

--THOUGH HE COULD HAVE DONE WITHOUT THE NAUSEATINGLY POTENT FRAGRANT HANKIES.

HE ORIGINAL OWNER OF THE RANCHERO IN THE LATE 1780s, HAD THE SECRET PASSAGE BUILT FROM THE HACIENDA TO THE SAN RAFAEL HILLS.

DIEGO'D FOUND NOTES ON THE TUNNEL'S CONSTRUCTION IN THE AREA HE NOW USES AS TORNADO'S STABLE.
THE TUNNEL WAS BUILT OUT OF *FEAR*; IT REQUIRED MORE WORK THAN MANY CABALLEROS PUT INTO RUNNING THEIR WHOLE HACIENDA. BUT IT WAS *SECRET* WORK THE DON (*THE TITLED LANDOWNER*) DID NOT WANT TO ENTRUST TO THE INDIAN VAQUEROS, EVEN THOUGH HE SPENT AS MUCH TIME WITH THEM AS WITH HIS OWN FAMILY.

OR IT WAS OTHER INDIANS THE DON FEARED. IN 1785, *TOYPURNIA*, A *GABRIELENO* WOMAN, COMMANDED AN UPRISING AT THE *SAN GABRIEL MISSION*. SHE WAS 24 YEARS OLD AT THE TIME. *TOYPURNIA'S* INTENT AT THE MISSION HAD BEEN TO KILL THE PADRES AND SOLDIERS SHE BELIEVED HAD *USURPED* HER TRIBE'S LAND.

TOYPURNIA *FAILED* IN HER ATTEMPT, BUT HIS POINT WAS WELL TAKEN, AND THUS THE FEAR THAT SUCH COULD HAPPEN WAS PLANTED LIKE FRUIT ROTTING IN MANY ANGELENOS' MINDS.

AND SO THIS TUNNEL WAS DUG IN SECRECY AND SWEAT, AN ESCAPE ROUTE TO THE DISTANT HILLS IF THE HACIENDA SHOULD COME UNDER ATTACK.

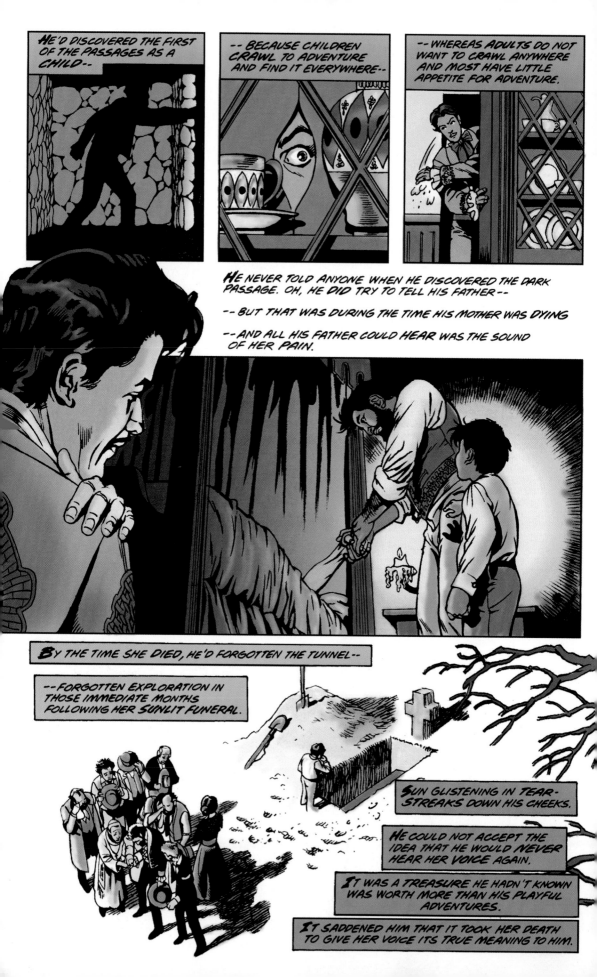

HE'D DISCOVERED THE FIRST OF THE PASSAGES AS A CHILD--

-- BECAUSE CHILDREN *CRAWL* TO ADVENTURE AND FIND IT EVERYWHERE--

-- WHEREAS *ADULTS* DO NOT WANT TO CRAWL ANYWHERE AND MOST HAVE LITTLE APPETITE FOR ADVENTURE.

HE NEVER TOLD ANYONE WHEN HE DISCOVERED THE DARK PASSAGE. OH, HE *DID* TRY TO TELL HIS FATHER--

-- BUT THAT WAS DURING THE TIME HIS MOTHER WAS *DYING*

-- AND ALL HIS FATHER COULD HEAR WAS THE SOUND OF HER *PAIN.*

BY THE TIME SHE DIED, HE'D FORGOTTEN THE TUNNEL--

--FORGOTTEN EXPLORATION IN THOSE IMMEDIATE MONTHS FOLLOWING HER *SUNLIT* FUNERAL.

SUN GLISTENING IN *TEAR-STREAKS* DOWN HIS CHEEKS.

HE COULD NOT ACCEPT THE IDEA THAT HE WOULD *NEVER* HEAR HER *VOICE* AGAIN.

IT WAS A TREASURE HE HADN'T KNOWN WAS WORTH MORE THAN HIS PLAYFUL ADVENTURES.

IT SADDENED HIM THAT IT TOOK HER *DEATH* TO GIVE HER VOICE ITS *TRUE* MEANING TO HIM.

MOST PEOPLE COULD NOT HELP BUT STARE AT LUCIEN MACHETE'S RUINED WRIST-STUMP WHEN THEY FIRST MET HIM.

THEY STARE, MESMERIZED, DRAWN LIKE FLIES TO DUNG, AT THE GRUESOME SIGHT.

THEY STARE AND CAN'T KEEP REVULSION OUT OF THEIR EYES. BUT EVEN IN STARING THEY ONLY SEE THE *WHOLE* OF THE AMPUTATION.

STARING IS NOT THE SAME AS *SCRUTINIZING.*

THEY CANNOT TELL A FAKE FLAB OF FLESH FROM REAL RUINED FLESH.

NO ONE HAS EVER SUSPECTED HE HAS A *METAL SHAFT* EMBEDDED IN HIS LOWER ARM.

THEIR REVULSION WOULD BE INTENSIFIED IF THEY KNEW HE HAD THE SHAFT SURGIC-ALLY IMPLANTED--

-- OR THAT IT HAD *SCREW-THREADS* ENABLING HIM TO ANCHOR *WEAPONS,* SMALL AND LARGE, ONTO HIS USELESS, OTHERWISE DEAD STUMP.

THE DARTS ARE DECEPTIVELY SMALL.

BUT THE HAVOC THEY WILL CAUSE WILL BE ENORMOUS.

THEY MIGHT EVEN BRING *DEATH* TO A FEW UNFORTUNATES.

THE *THREAT* OF DEATH IS OFTEN NECESSARY TO CREATE A HERO OR A VILLAIN.

ODD HOW THAT WORKS.

TIME TO GO SEE DON ALEJANDRO, AND HE SMILES, NOT JUST BECAUSE A SMILE IS NEEDED FOR HIS ROLE AS BENEFACTOR--

-- BUT BECAUSE HE TRULY DOES LIKE DON ALEJANDRO, THE CRUSTY, OPINIONATED OLD BUZZARD.

GOOD DAY, EXCELL-ENCY. YOUR COACH TO TAKE YOU TO THE DE LA VEGA HACIENDA IS ALL PREPARED.

GRACIAS, SERGEANT. AND GRACIAS FOR YOUR WARM GREETING.

PERHAPS TONIGHT WE MIGHT SHARE A *GOBLET* OF WINE AT THE TAVERN.

WOULD YOU FIND THAT ACCEPTABLE?

OH, MOST ASSUREDLY, EXCELLENCY. ONLY TO BE *SOCIABLE*, YOU UNDERSTAND.

INDEED I DO.

What are you doing, Regency Administrator?

Why don't the vultures fly away?

Because we are birds of a feather. They smell one of their own.

DON ALEJANDRO HAD EXPECTED HIS SON TO RETURN FROM UNIVERSITY LIFE IN SPAIN AS THE SAME PERSON HE SENT ABROAD FOR EDUCATION.

WISER, A FEW YEARS OLDER, BUT STILL THE SON HE HAD KNOWN WHEN DIEGO WAS GROWING UP.

DIEGO! WHERE THE DEVIL ARE YOU?

A SON ABLE TO EDUCATE HIM--

--MAKE HIM BETTER AT UNDERSTANDING THE COMPLEXITY OF THINGS THAT MIGHT AFFECT THEIR LIVES ON THE RANCHERO.

NOW, HE HAD A SON WHOSE NOSE WAS ALWAYS IN A BOOK--

--WHO LOVED WORDS MORE THAN HOW TO SIT IN A SADDLE ON A FINE HORSE.

NOW, DIEGO MOVES WITH DANDIFIED EXAGGERATION--

--AND WASTES TIME DRAWING SQUIGGLES IN PEN AND INK THAT INSULT PEOPLE.

DON ALEJANDRO OFTEN WANTED TO EMBRACE HIS SON; BUT THE DIFFERENCES IN THEIR NATURES, AS TO WHAT THEY SAW AS IMPORTANT, WERE TOO WIDE--

HEAVENS PRESERVE ME!

--AND SO HE KNEW HE WOULD BE SURLY AND IMPATIENT IN HIS SON'S PRESENCE.

--WOULD VENT HIS ANGER AT SUCH INSULT AND INSIGNIFICANT BEHAVIOR.

THE REGENCY ADMINISTRATOR IS DUE HERE ANY MINUTE AND THIS...

THIS TRASH OF DIEGO'S IS LYING ABOUT.

SUPPOSING HE'D HAVE SEEN IT?

HE'D BE JUSTIFIED IN CHALLENGING DIEGO TO A DUEL!

IN THE SOLITUDE OF THE NIGHT, THERE WERE MOMENTS WHEN ALEJANDRO WOULD REPRIMAND HIMSELF AND REGRET HIS IMPATIENCE IN THE DAY.

BERNARDO CANNOT EXPRESS HIS *ANXIETY* ALOUD.

COMMANDS THUNDER IN HIS HEAD, AS AUTHORITARIANLY ARRESTING AS DON ALEJANDRO AT HIS LION'S ROAR BEST.

"COME BACK, DIEGO! I CANNOT KEEP YOUR FATHER AT BAY FOREVER, YOU KNOW THAT!"

HIS ANXIETY DOES NOT NEED VOICE, IT IS CLEARLY STATED IN HIS PACING, HIS FIDGETING HAND, IN HIS SOLICITOUS EYES.

BUENAS DIAS, BERNARDO.

HOW ARE YOU DO--

OKAY! SLOW DOWN. WHERE ARE YOU DRAGGING--

OH, TO MY FATHER! YOU DO AN *EXCELLENT IMITATION* OF HIM BEFORE HE'S HAD HIS MORNING COFFEE, YOU KNOW.

OR WHEN HE'S SEEN *MY LATEST* PICTURE STORY.

AH! HE'S AWAITING HIS NEWLY FOUND FRIEND, LUCIEN MACHETE.

TOO BAD THE MAN HAS TO BE AN OLD ENEMY OF ZORRO'S.

WHAT'S WRONG?

MY FATHER WANTS ME TO *WHAT?*

OH, I SEE. GO TO THE MATANZAS... *SLAUGHTER-INGS...* WITH THEM.

I CAN'T GO TO THE *CALAVERAS...* THE SLAUGHTER CORRAL... AS DIEGO, BERNARDO.

IF MACHETE IS GOING TO BE THERE, SO MUST ZORRO.

THIS MAN IS A *KILLER* WITHOUT CONSCIENCE. DON'T LET HIS VENEER OF REFINERY FOOL YOU.

I *KNOW* YOU SEE UNDER THE SURFACE OF PEOPLE, DON'T BE SO QUICK TO TAKE OFFENSE.

AH! WOULD I BE OFFEND-ED IF *YOU* SAID SOME-THING LIKE THAT ABOUT ME?

OKAY, YOUR POINT IS WELL TAKEN.

THE FACT IS, MACHETE HAS COME TO LOS ANGELES FOR BITTER PURPOSES.

SOMEHOW, HE HAS ALL THE PAPERS TO PROVE HE REPRESENTS THE KING IN SPAIN AND THE MINISTER GENERALS IN MEXICO.

I'D GIVE UP A KISS FROM LADY RAWHIDE TO LEARN HOW HE MANAGED THAT ENORMOUS TRICK.

THE NIGHT HE SHOT ME WITH THAT INCREDIBLE SPEAR, HE PROMISED TO DELIVER MISERY TO OUR PUEBLO, AS IF HE WERE SOME QUIETLY DEMENTED PROPHET.

HE ALSO PLEDGED TO DESTROY ZORRO FOR THE LOSS OF HIS HAND, BUT I THINK MORE FOR SOME INSANELY PERCEIVED AFFRONT TO HIS PERSON.

MACHETE WASN'T MAKING IDLE THREATS. HE WILL TRY TO FULFILL ALL HIS DIABOLICAL PROPHECIES.

I DON'T KNOW WHAT HE HAS PLANNED, BUT I SUSPECT WE WILL GLIMPSE ITS MAGNITUDE AT SUCH A FUNCTION AS THE MATANZA.

THE SLAUGHTERINGS HAVE BEEN GIVEN SO MUCH FANFARE AND WILL HAVE SUCH PUBLIC ATTENDANCE.

THIS IS A DAY FOR THE DONS TO SHOW OFF THEIR RANCHING TECHNIQUES TO IMPRESS THE "FOREIGN EXPERT."

MACHETE WILL TAKE ADVANTAGE OF THE HIGH VISIBILITY OF THE MOMENT. I'M SURE OF IT. THERE MIGHT BE MORE THAN ONE TYPE OF SLAUGHTERING TODAY... FOR MACHETE IS A MAN WHO DELIGHTS IN SLAUGHTERINGS, BOTH SUBTLE AND BLOOD SPLATTERING.

THEREFORE, IT MUST BE ZORRO, NOT DIEGO, WHO WATCHES WHAT HAPPENS AT THE MATANZA.

THERE YOU ARE! *ABOUT TIME!* DON'T YOU REALIZE, DIEGO, THAT LUCIEN IS DUE TO ARRIVE AT ANY MOMENT?

I DIDN'T REALIZE YOU AND THE REGENCY ADMINISTRATOR WERE ON A *FIRST NAME* BASIS.

ARE YOU READY TO ACCOMPANY US TO THE MATANZA?

I WAS SO LOOKING FORWARD TO *GOING*, FATHER! BUT I MUST CONFESS TO FEELING RATHER *QUEASY* TODAY.

I THINK SOMETHING I ATE GAVE ME A *GHASTLY* STOMACH DISTRESS. LOOK AT MY EYES, YOU CAN TELL I HARDLY SLEPT A WINK DURING THE NIGHT.

PLUS, I HAVE THE MOST EXCRUCIATING HEADACHE. IT FAIRLY *THROBS* WITH PAIN.

THAT'S WHAT HAPPENS WHEN YOU *STRAIN* YOUR EYES DRAWING *IMBECILIC* PICTURES THAT I FIND PERSONALLY DEMEANING.

YOU ARE GOING! I WON'T LET YOU EMBARRASS ME THIS WAY!

HONEST, FATHER. I AM NOT TRYING TO EMBARRASS YOU.

HOW ABOUT *THIS?* IF *YOU* DON'T BRING UP MY ATTENDANCE IN FRONT OF THE REGENCY ADMINISTRATOR, I WON'T *MENTION* IT.

THEN, IT WON'T BE AN ISSUE FOR *EITHER* ONE OF US.

I BURNED IT, YOU KNOW.

BURNED WHAT?

YOUR *NEWEST* INSULT TO GOOD TASTE AND JUDGMENT.

MY *DRAWINGS!*

EXACTLY! NOW I SEE YOU ARE AS *UPSET* AS I AM!

GOOD! IT'S GOOD I SHOULD BE ABLE TO ELICIT THE SAME EMOTION FROM YOU THAT YOU SO OFTEN SUCCEED IN *PROVOKING* FROM ME.

YOU DID NOT *NEED* TO DO THAT, FATHER!

I TRIED EVERYTHING ELSE, IT DID NOT SEEM TO WORK. THIS TIME YOU SEEM TO HAVE AT LEAST *HEARD* ME!

HERE COMES THE REGENCY ADMINISTRATOR NOW.

ONE LOOK AT YOU, HE'LL KNOW YOUR *INDOLENT ATTITUDE* WITHOUT MY SAYING A WORD.

LUCIEN MACHETE IS GLAD TO MOUNT A HORSE. HE HAS RIDDEN IN TOO MANY *PLUSH* CARRIAGES OF LATE.

SOFT SEATS ARE FINE FOR FEMALE COMPANIONSHIP, TO MAKE ONE'S WAY WITH A LADY SO INCLINED--

-- WHILE MOVEMENT AND CLOSED DOORS ASSURE PRIVACY.

MY SON, DIEGO, WILL NOT BE COMING WITH US. HE'S TAKEN TO HIS BED.

NOTHING SERIOUS, I TRUST?

MAYBE I MAKE IT MORE SERIOUS THAN IT SHOULD BE. MAYBE, FOR *BOTH* OF US.

IT IS ALWAYS OUR *FAMILIES* THAT ARE ABLE TO HURT US MOST DEARLY, ISN'T IT? ODD HOW THAT SHOULD BE.

MY *WIFE* WILL BE COMING UP FROM *MEXICO* SHORTLY TO BE WITH ME. IF ALL GOES WELL, SHE SHOULD BE HERE WITHIN THE MONTH.

SINCE I INTEND TO BE HERE FOR AWHILE, I FEEL IT BETTER SHE BE AT *MY SIDE.* IT HELPS SETTLE ME INTO A DAILY ROUTINE.

IT'S A *MIXED BLESSING,* HOWEVER, FOR WOMEN DO WANT FOR COMFORTS AND LUXURIES, I'M SURE YOU ARE AWARE.

NO, I'M NOT AWARE. MY WIFE WAS USED TO *HARDSHIP* AND DOING WITHOUT.

IT IS *HER* SPIRIT, AS MUCH AS *MINE,* THAT MADE THIS RANCHERO POSSIBLE.

MEET ME IN THE *RAVINE* UP FROM THE CALAVERAS, BERNARDO.

IT'S A PERFECT, SECLUDED SPOT TO KEEP AN EYE ON MACHETE AND MY FATHER AND THE SLAUGHTERINGS.

SI, TORNADO! *I'M* AFRAID WE DO HAVE TO GO AGAIN SO SOON.

NO REST FOR US TODAY... BUT AT LEAST NO ONE IS SHOUTING IN YOUR FACE ABOUT WHAT A DIS-APPOINTMENT YOU ARE.

FATHER AND ENEMY NEVER SEE THE FOX.

OR ARE AWARE OF HIS PAIN.

AND THE SLAUGHTERINGS HAVE BEGUN BEFORE REACHING THE PLACE OF ROTTING MEAT AND BARREN SKULLS.

THE SMALL SLAUGHTERINGS SACRIFICING LOVE.

THE ONLY CROWS THAT ARE SILENT ARE THE ONES JABBING HARD BEAKS INTO ROTTING CARCASSES FOR JUICY OFFAL.

TERRIBLE INCIDENT IN A PLACE OF SKULLS

THE SMELL OF FRESHLY SPILLED BLOOD FROM THE SLAUGHTER CORRAL FILLS THE WARM AIR EVEN TO THE DISTANT RAVINE.

ZORRO STANDS IN THE STIRRUPS SO HE MIGHT VIEW HIS FATHER BETTER.

THE WOUND IN HIS BUTTOCKS SENDS A MESSAGE OF STIFFENING MUSCLE.

THE WOUND GIVEN TO HIM BY MACHETE, WHO STANDS IN SUCH CLOSE PROXIMITY TO HIS FATHER.

I DON'T KNOW WHAT MACHETE'S GOING TO TRY TODAY, BERNARDO.

BUT I KNOW HE'S GOING TO DO IT HERE, AND WHATEVER IT IS--

--IT WILL BE QUICK, TERRIFYINGLY VIOLENT, AND HAVE TRAGIC CONSEQUENCES.

I TRULY BELIEVE THIS.

THERE ARE SO MANY *SKULLS.*
SKULLS STREWN ABOUT THE GRASSY SPACE
BEYOND THE SLAUGHTER CORRAL--
--GREEN BLADES PROTRUDING THROUGH
EMPTY EYE-SOCKETS --
-- THE BONE PICKED CLEAN BY SCAVENGERS,
DOGS, CROWS, GRIZZLY BEARS FROM THE
UPPER WOODED AREAS.

SKULLS CLOSER TO THE KILLING GROUND,
THE STRIPS OF MEAT DRIED TOUGH AND STUCK
TO BONE AMIDST INNARDS TURNED JUICELESS
AND CRUSTED.
THE FRESHER SLAUGHTERINGS ARE NEARER
THE MILLING PENS.
THE NOISE IS AS STRONG AS THE SMELL OF
BLOOD; DOGS HOWLING IN ANTICIPATION;
CROWS CAWING IN INCESSANT IMPATIENCE;
LONG-HORNED CATTLE VOICE INSTINCTIVE
FEAR.

NONE OF THE MEN SEEM BOTHERED BY THE NOISE OR BLOOD. NOT THE INDIAN WOMEN SEWING UP COW-HIDES TO MAKE SACKS TO SCOOP UP THE MUSHY TALLOW AND LARD TO MAKE CANDLES AND SOAP.

NOT THE INDIAN BUTCHERS OR THE INDIAN VAQUEROS, WHO DID MOST OF THE RIDING, ROPING AND KILLING.

THEY WERE THE EXPERT COW-HERDERS PERFORMING UNDER THE WATCHFUL EYE OF THEIR MAJOR DOMO AND THE DONS, WHO OWNED THE HACIENDAS, AND THUS THE LAND, AND THERE-FORE THE CATTLE, AS WELL.

DON ALEJANDRO IS PREOCCUPIED WITH THE ABSENCE OF HIS SON, DIEGO.

DIEGO SHOULD BE AT IS SIDE WITH THE REGENCY ADMINISTRATOR, TO SHARE THE VISIT OF THIS DIGNITARY, TO SHARE IN THE RITUAL OF THE MATANZA.

DIDN'T DIEGO UNDERSTAND THAT THIS PUT FOOD ON THEIR TABLE?

GAVE THEM PRODUCT FOR TRADE WITH THE SAILING SHIPS?

PROVIDED FOOD FOR THE PADRE AND THE MISSION INDIANS?

HERE, IN THIS PLACE OF SKULLS, THEY KEPT ALL OF LOS ANGELES, THEIR WAY OF LIFE, ALIVE!

BARNABE CRESPI LOVES HORSES.

SOMETIMES HE HAS DIFFICULTY BELIEVING HE IS THE MAJORDOMO OF THE DE LA VEGA RANCHERO--

--THAT HE IS MORE ESSENTIAL TO OVERSEEING THE DAILY REGIMEN CONCERNING THE VAQUEROS AND CATTLE AND HORSES FOR DON ALEJANDRO THAN ANY OTHER MAN.

HE SUPPOSES THE REASON IT IS SO DIFFICULT FOR HIM TO ACCEPT IS THAT HE CAN STILL RECALL THE STORIES HIS GRANDFATHER TOLD HIM--

--MANY TIMES OVER, BECAUSE THE OLD MAN LOVED TO TELL STORIES OF HIS LIFE--

--AND ALWAYS TOLD EACH ONE AS IF HE HAD NEVER TOLD IT TO YOU BEFORE.

REGENCY ADMINISTRATOR, WE WOULD LIKE YOU TO BE OUR HONORARY *JUEZ DE CAMPO*... OUR FIELD JUDGE... AS OUR MEN GO TO WORK FOR OUR PUEBLO AND YOUR EDIFICATION.

I AM HONORED. WHAT WAS YOUR NAME AGAIN?

BARNABE CRESPI, SEÑOR.

AND I THANK YOU, DON ALEJANDRO, FOR INVITING ME TO ATTEND THE MATANZA.

YOU HAVE NOTHING TO THANK ME FOR, SERGEANT GARCIA. AFTER ALL--

--YOU ARE ESCORTING THE ADMINISTRATOR.

WE'RE GLAD YOU ARE HERE. I HOPE YOU ENJOY YOURSELF.

OH, I KNOW I WILL, BUT WHERE IS DON DIEGO?

THE ONE PLACE HE'S NOT...

IS HERE.

MACHETE'S FINGERS TRACE LOVINGLY OVER THE DEAD, MUTILATED FLESH OF HIS WRIST.

HE IS AMUSED BY THE FLIES' HASTY FLIGHT. SCATTER AND COME BACK, WHAT THE HELL DO I CARE?

UNDER THE FAKE FLAB OF FLESH HE CAN FEEL THE LETHAL DARTS.

HE'LL ALLOW THE BLOOD-LETTING TO BEGIN, LET THE VAQUEROS EXHIBIT THEIR SKILL.

AND THEN HE WILL BEGIN THE REAL SHOW!

WE ARE ABOUT TO RELEASE THE FIRST OF THE CATTLE, REGENCY ADMINISTRATOR.

WELL, FOR HEAVEN'S SAKE, DON'T LET ME HOLD THINGS UP, BARNABE.

TELL ME, SERGEANT. HAS ANYONE HEARD ANYTHING ABOUT THAT MOONSTALKER RENEGADE WHO, I TAKE IT, WANTED TO BLOW MY ASS TO KINGDOM COME!

YOU SHOULD NOT JOKE, EXCELLENCY. HAD ZORRO ALSO NOT WANTED TO ATTACK YOU, I FEAR THIS LUNATIC MIGHT HAVE SUCCEEDED.

IN OTHER WORDS YOU'VE HEARD NOTHING OF HIM.

WE NEVER EVEN HEARD OF A MOONSTALKER BEFORE.

AND I GUESS WE WOULD NOT HAVE KNOWN NOW IF ZORRO HAD NOT SAID THE NAME TO THE CAPITAN.

MARK MY WORDS, I AM FAR FROM A PROPHETIC MAN...

...BUT WE WILL HEAR FROM THIS MOONSTALKER AGAIN. YOU WAIT AND SEE.

THE GRIZ IS DRAWN FROM THE HIGH MOUNTAINS BY THE *ALLURING SCENT* OF RAW FLESH AND FLOWING BLOOD--

--BECKONING TO IT AS THE AROMA OF COOKING WOULD TO A HUNGRY MAN.

IT IS NINE FEET TALL, ONE THOUSAND POUNDS OF WILD FEROCITY.

IT IS MAGNIFICENT--

--AND AWESOME, IN THE TRUE SENSE OF THE WORD--

--AND IF IT COMES UPON YOU WITHOUT WARNING AND IN FURIOUS MOTION, *TERRIFYING!*

IT HAS COME TO EAT, NOT TO FIGHT--

--BUT IT WILL **FIGHT** ITS WAY THROUGH WHATEVER STANDS IN ITS WAY TO

EAT!

THE MATANZA WILL OFFICIALLY BEGIN WHEN I *DROP* MY HAND. BE READY, GABRIEL.

WHAT ARE YOU TRYING TO DO, *BARNABE*, MAKE THE REGENCY ADMINISTRATOR THINK I AM A *NOVICE*?

DROP YOUR STUPID HAND AND BE DONE WITH IT!

GABRIEL CÁDIZ IS A *NUQUEA-DORES*... A NECKER.

HE IS PROUD OF HIS *SKILL* ON HORSEBACK.

HE IS PROUD OF HIS *ACCURATE EYE* AND PRECISE SKILL WITH A KNIFE.

AT FULL GALLOP, HE CAN SIGHT, STRIKE, KNIFE BLADE PIERCING THE NAPE OF THE COW'S NECK--

--AND LEAVE IT DYING IN HIS WAKE, HIS HORSE NEVER BREAKING STRIDE!

THE HORSES ONLY HAVE TWO SECONDS WARNING OF A *DOWN WIND SHIFT* IN THE AIR. BEFORE THE BEAR ERUPTS FROM THE TREES, THE *BLOOD-SCENT* OF FRESH KILL STRONG IN ITS NOSTRILS!

THE BEAR, FOR HIS PART, IS NOT EVEN AWARE OF THEM UNTIL BERNARDO'S HORSE *SHRIEKS* AND *REARS*!

THE GRIZZLY SENSES MOVEMENT AND DANGER AND REACTS ACCORDINGLY. ONE *SWIPE* AND ITS CLAWS NEARLY *GUT* THE SOFT UNDERBELLY OF THE HORSE.

RII-IIPP

ZORRO TRIES TO RETAIN THE *DISCIPLINE* OF CONCENTRATION HE HAS PRACTICED MANY TIMES.

IF HE *PANICS*, HE IS *DEAD*—

—DEAD AS THE COW THE *NUQUEADORE'S* BLADE JUST KILLED!

EASY, *TORNADO!*

THIS IS NO TIME TO BE *THROWN!*

WATCH HOW QUICKLY OUR *PELADORES* STRIP THE HIDE FROM THAT COW.

I HAVE TO ADMIT, YOUR *SKINNERS* ARE QUICKER THAN THE CROWS.

THEY KNOW THOSE *HIDES* ARE VERY VALUABLE TO US WITH THE *TRADING SHIPS*.

BEING AS *ISOLATED* AS OUR PUEBLO IS, I'M SURE YOU REALIZE IT IS ONLY THROUGH THE SHIPS AND TRADE THAT WE CAN GET *COMMODITIES* NOT PRODUCED IN THIS COUNTRY.

VERY EFFICIENT. AND YOU KNOW WHAT IMPRESSES ME MOST?

NO, LUCIEN... WHAT?

NOT A SINGLE PERSON WAS *HURT*.

WITH THE WILD CATTLE WE DEAL WITH HERE WE DO HAVE SOME ACCIDENTS, I WON'T CLAIM WE DON'T.

WELL, HOPEFULLY... WE'LL HAVE NONE TODAY.

HE HAS TO KEEP HIS FRONT TO THE GRIZZLY.

KEEP HIS EYES LOCKED ON IT, GAUGING ITS MOVEMENT, DEDUCING WHEN IT WILL STRIKE.

HE REALIZES THE BEAR ONLY WANTS TO REACH THE OFFAL AND RAW MEAT BEYOND HIM—

—BUT THAT WON'T MAKE HIM ANY LESS DEAD.

ONE SLASH OF CLAW THAT MANAGES TO SCORE FLESH WILL GOUGE STRAIGHT TO BONE!

RAMON SANTIAGO HEARS THE PANICKED CRIES OF THE AGITATED CATTLE.

HAS HEARD THE BRIEF RUSH OF HOOFS OF THE FIRST COW TO FALL TO THE KNIFE.

THE ABRUPT QUIETENING AS THE CHASE ENDS. FOR THOSE FEW SECONDS EVEN THE CROWS ARE SPEECHLESS.

Damn! The old man just drags me out here! Doesn't give me any say at all!

HEARS THE KNIVES OF THE TASAJEROS CUTTING THE FRESH KILL TO STRIPS OF RAW MEAT.

CHOICE CUTS FOR DRYING AND COOKING.

LORD JESUS! I STUMBLE LIKE A THREE YEAR OLD JUST LEARNING TO WALK!

AND RAMON SANTIAGO FEELS AS IF EVERYONE'S EYES ARE ON HIM.

EYES WATCHING WITH PITY OR AMUSEMENT.

IN HIS DARKNESS, THE WHOLE WORLD IS EYEWITNESS TO HIS AWKWARDNESS--

--AND PERSONAL HELL.

HE COULD REACH FOR HIS *REATA*, BUT THIS GRIZZLY IS MONSTROUS IN SIZE AND WEIGHT-- AND ONE MAN CAN'T POSSIBLY YANK IT OFF ITS FEET, NO MATTER WHAT EXPERTISE HE HAS WITH THE *LARIAT*.

DON'T TRY TO HELP, BERNARDO!

GET BACK DOWN AND LIE DEAD!

MOVE-MENT ONLY ATTRACTS HIS ATTENTION--

--AND THERE IS NOTHING YOU CAN DO ON FOOT!

IT MOVES QUITE AGILELY FOR SOMETHING SO HUGE.

HE HAS HEARD MANY *VAQUEROS* DEBATE WHICH IS MORE *DANGEROUS*, A WILD GRIZZLY OR AN UNTAMED BULL, WITH BOTH SIDES HAVING MERITS FOR THEIR ARGUMENTS.

STILL, THE PAWS WICKEDLY SLICING THE AIR, SEEKING FLESH!

AND COMING TOO DAMN CLOSE!

TIME TO RIP BACK THE FAKE FLESH THAT LOOKS AS REPULSIVE AS HIS REAL DEAD FLESH. TIME TO FIRE THE DART INTO THE TARGET HE HAS PICKED.

THIS BULL IS ALREADY BAD-TEMPERED AND VERY CLOSE TO THE GATE THAT IS ONLY LOOSELY HELD BY BARNABE CRESPI!

HE HITS EXACTLY WHERE HE AIMS.

NO ONE WILL DETECT THE DART DIGGING STEEL BEHIND THE EAR.

BARNABE MAY WELL BE THE BULL'S VICTIM!

IF SO, NOT A BAD CHOICE.

AND CERTAINLY DON RAMON IS NOT FAR BEYOND, ALSO A POSSIBILITY FOR MAIMING OR DEATH!

MAYBE BOTH WILL FALL TO ITS BERSERK CHARGE!

PULL THE LENGTH OF TWINED RAWHIDE TAUT!

NOW YANK IT FREE OF THE SNOUT!

TENDER, BLOOD-STREAKED PINK IS EXPOSED.

THE BEAR VOICES ITS PAIN AND RAGE AND INDIGNATION!

ITS ROAR CURIOUSLY REMINDS HIM OF THE STORM-LASHED OCEAN WAVES FILLING THE WORLD!

NOW, TORNADO! MOVE IN, AND ALSO MOVE OUT QUICKLY!

DON'T MAKE A MIS-STEP, OR WE ARE BOTH GOING DOWN!

AND IF WE DO, I WOULDN'T WANT TO WAGER ON OUR CHANCES OF GETTING BACK UP!

IT IS A DANGEROUS DEFENSE.

THE REPEATED QUICK MOVEMENT INWARD! RELYING ON THE SURENESS OF WRIST AND EYE.

THE EQUALLY QUICK DODGE OUT-WARD.

HE TRUSTS TORNADO MORE THAN HE DOES HIS OWN ARM AND SKILL WITH THE WHIP.

THE DARK HORSE HAS NEVER FAILED HIM.

TIME TO GIVE IT UP, SEÑOR BEAR.

YOU AND I BOTH KNOW THAT NOSE REALLY HURTS!

THE BEAR GIVES IN TO THE RELENT-LESS SNAP AND STING OF THE WHIP.

NOW, SKEDADDLE! COME BACK LATER, WHEN IT'S QUIET, AND THE PICKINGS ARE EASIER.

DAMN! MACHETE CURSES THE WORD IN HIS HEAD, WISHING THE VICTIM WERE SOMEBODY OTHER THAN THE OLD MAN!

HE MUST BE GROWING SOFT. TIME WAS HE COULDN'T CARE LESS ABOUT THE OLD MAN, ONE WAY OR THE OTHER.

AND HE CAN'T QUITE FIGURE IT, BECAUSE DON ALEJANDRO SURE DOESN'T REMIND HIM OF HIS OLD MAN IN MEDILLIN, SPAIN.

AND ABRUPTLY WONDERS IF HIS FATHER IS STILL ALIVE, STILL WORKING THE BARREN LAND.

AND ANYHOW, BY THE TIME HE'S FINISHED, LOS ANGELES WILL ALL BE A PLACE OF SKULLS.

SO MUCH BLOOD, IN A PLACE ACCUSTOMED TO BLOOD, YET STILL A TERRIBLE INDICTMENT--

--SCREAMING OF THE FINALITY OF DEATH!

ZORRO ISN'T SURE WHAT MAKES HIM LOOK BACK TOWARD THE SLAUGHTER CORRAL. PERHAPS IT IS JUST THAT HE HASN'T LOOKED IN THAT DIRECTION SINCE THE GRIZZLY'S ATTACK.

HE CANNOT SEE THE BLOOD---CAN ONLY SEE THE TINY FIGURES.
SEE THE ONE FIGURE SHAKEN LIKE A *VIOLENTLY ASSAULTED* MARIONETTE. HE IMMEDIATELY RECOGNIZES MACHETE BY HIS *SIZE.*

HE DOES NOT SEE THE BLOOD, BUT HE KNOWS IT IS THERE, *HAS TO BE THERE!*

THERE MUST BE BLOOD STAINING THE COLORS OF HIS FATHER'S OUTFIT.

IT IS THE COLOR OF THE CLOTHES THAT TELLS HIM WHO IS IMPALED ON THE BULL'S HORNS, NOTHING ELSE.

NO! STAY AWAY FROM HIM, YOU BASTARD!

STAY AWAY FROM MY FATHER!

CLOSING IN!
THE SECONDS SEEM
SO LONG.

HE STILL HAS THE DIS-
HEARTENING IMPRES-
SION THAT HE CAN
SEE EVERYTHING, ONLY
CLOSER NOW.

HIS FATHER STILL
ATTACHED TO THE BULL,
AS IF THE POINTED HORN
BURIED BLOODILY
IN HIS GUT IS INSEPAR-
ABLE!

AND HE IS SCREAMING
IN HIS HEAD, "PLEASE,
GOD, PLEASE, LET HIM
BE ALL RIGHT!"--

--ALL THE WHILE KNOW-
ING MACHETE SOME-
HOW MADE THIS
HAPPEN--

--NOT KNOWING HOW
HE COULD DO SUCH A
THING, CONTROL A
WILD ANIMAL SET FOR
SLAUGHTER--

--BUT KNOWING DAMN
WELL THAT HE DID!

BARNABE CRESPI IS AGHAST. HE IS DON
ALEJANDRO'S MAJORDOMO, THE MAN
ENTRUSTED WITH THE DE LA VEGA RANCHERO'S
DAILY OPERATION, AND HE HAS BEEN UNABLE
TO PREVENT THIS TRAGEDY.

IT IS ALL HAPPENING TOO FAST. ONE MOMENT
SERGEANT GARCIA IS SQUEAMISHLY SCRAP-
ING COW CRAP FROM HIS BOOT--AND THE
NEXT THERE IS RAPID MOVEMENT AND
SHOUTING--AND DON ALEJANDRO IS SOMEHOW
GORED OPEN, SO MUCH BLOOD--

--AND THEN THERE IS EL
ZORRO CHARGING TOWARD
THEM, BUT HOW CAN EVEN
ZORRO STOP SUCH FLOW
OF BLOOD?

LUCIEN MACHETE DIGS HIS HEELS INTO THE SOFT EARTH, GOUGING DEEP, BUT IT SCARCELY SLOWS THE BULL.

THIS IS CERTAINLY A TIME WHEN IT WOULD HELP TO HAVE THE USE OF TWO HANDS.

LOT OF SITUATIONS, HE CAN DO BETTER WITH THE ONE AND HIS LETHAL ATTACHMENTS, BUT NOT AT THIS MOMENT.

AT THIS MOMENT, THERE IS ONLY HIS OWN WILL AND STRENGTH AND WITS KEEPING HIM FROM DEATH.

HE IS AFRAID THE OLD MAN IS ALREADY DEAD; THE OLD MAN WHO NEVER SEEMED SO OLD AND WHOM HE SHOULDN'T GIVE ONE DAMN ABOUT.

EXCEPT IF HE DIDN'T, WHICH HE SHOULDN'T, THEN WHY IS HE AFRAID?

He can't recall ever being afraid for other people.

This must be some momentary debilitation, couldn't be anything more.

His wrist stump is slipping, going to lose hold if he doesn't do something quick

Only has the trajectory darts loaded inside his lower arm.

On the other hand (or lack of it)--

--He doesn't have to fire those darts.

Simply extend one of the sharpened dart-edges past the nerve-dead flesh.

Preliminary slaughtering.

Jab upward, yank to the right forcefully.

Tear through soft, vulnerable throat.

Not a neat tear, no precision to the cut--

--But it'll do the job!

THE BLOOD IS WARM AND WELCOME.

IT IS A COMFORTING SHOWER OF GORE, COMFORTING BECAUSE HE KNOWS WHAT IT SIGNIFIES.

HIS ARMS REFUSE TO YIELD, THOUGH THEY ARE AWASH IN WARM RED.

GIVE, YOU SON-OF-A-BITCH! HE DEMANDS OF THE CREATURE.

GIVE IT UP, ALREADY, YOU'RE DEAD, THE BLOOD GUSHING SAYS YOU ARE DEAD!

GIVE UP THE GHOST AND ROLL OVER!

AND, ALL AT ONCE, THE FIGHT AND FURY IS GONE OUT OF THE BULL.

IT TWITCHES IN LAST DEATH SPASMS.

BLOOD IS THICK IN HIS NOSTRILS, A SMELL AS ANCIENT AS FIRST LIFE, FIRST CONFLICT.

ONE SURVIVES.

THE QUESTION IS: IS THE OLD MAN DEAD? AND IF HE ISN'T WOULD HE BE BETTER OFF IF HE WERE?

HE IS NOT KNOWN FOR A GENTLE TOUCH, WITH FAMILY OR LOVERS -- YET LIFTS THE LIMP HEAD WITH UNCHARACTERISTIC CARE AND CONCERN.

T'CLOPT
T'CLOPT

A HORSE'S HOOFBEATS? RESCUERS? THE MAJORDOMO, THAT CRESPI FELLOW. THE NUQUEADORES, CADIZ?

CAN'T BE GARCIA, PROBABLY STILL CLEANING COW-FLOP FROM HIS BOOTS.

HE LOOKS UP FROM DON ALEJANDRO'S FRIGHTFUL WOUND AND IS LEGITIMATELY SURPRISED--

--AND DELICIOUSLY DELIGHTED!

HE FEELS THE WETNESS, KNOWS IT IS HIS FATHER'S BLOOD--
--THE WETNESS CALLS TO HIM WITH FAMILIAR URGENCY--
--BUT HE DARE NOT TURN TO LOOK AT HOW TERRIBLE THE WOUND IS.

LET ME SEE HOW THE OLD MAN'S DOING.

STAY AWAY FROM HIM, MACHETE!

OH, NO. I CAN'T POSSIBLY DO THAT.

AFTER ALL, I'M HIS SAVIOR.

ZWIPP

I'LL KILL YOU HERE! *NOW!*

THE DAY HAS BEEN SLAUGHTERED OF REASON. SERGEANT GARCIA WATCHES ZORRO ACT THE WAY COMMANDANTE MONASTERIO ALWAYS ACCUSES THE FOX OF ACTING.

A TERRIBLE THOUGHT THAT HE HATES HITS HIM: LIE ABOUT SOMETHING LONG ENOUGH AND PERHAPS YOU CAN CAUSE IT TO COME TRUE.

SEÑOR ZORRO, CAN YOU HEAR ME? HAVE YOU GONE LOCO IN THE HEAD? OUR REGENCY ADMINISTRATOR JUST SAVED DON ALEJANDRO'S LIFE!

PLEASE, FOR HEAVEN'S SAKE, PUT AWAY THE SWORD! YOU SHOULD BE THANKING HIM, NOT KILLING HIM!

BERNARDO'S WHOLE BODY STRAINS FORWARD, AS IF HE IS ALREADY RACING ACROSS THE SKULL STREWN EXPANSE.

HE WANTS TO RACE TO THESE TWO MEN WHO HAVE MEANT SO MUCH TO HIM SO MUCH OF HIS LIFE.

RACE TO DIEGO. HE DOESN'T KNOW WHAT HE CAN DO TO HELP HIM.
IT IS AN ABSURD IMPULSE, FOR HE CAN'T FIGHT MACHETE BETTER THAN DIEGO, THAT'S A FACT.

RACE TO ALEJANDRO. THE MAN IS 61 YEARS OLD, IS HE TO DIE AT THAT AGE?
HE NEVER THOUGHT ALEJANDRO COULD DIE, BUT NOW HE IS LYING CRUMPLED ON THE SUNLIT CALA-VERAS, HUMAN BLOOD, ALEJANDRO'S BLOOD, FRESH IN THE PLACE OF SKULLS, LORD KNOWS HOW BADLY HURT.

BERNARDO WANTS TO SHOUT TO THE WORLD HIS PAIN AT SUCH KNOWLEDGE--
--BUT HE HAS NO VOICE--
--AND HE CANNOT MOVE--
--BECAUSE TO APPEAR WOULD BE TO BETRAY DIEGO.
WHY WOULD BERNARDO SHOW UP WITH ZORRO?
NO ONE WANTS THAT QUESTION ASKED.

THE DESIRE IS SO DEEP TO CARVE THE CONDESCENDING SMILE FROM MACHETE'S FACE.

THERE IS ALSO THE DESIRE TO TURN TO HIS FATHER, SEE HOW TERRIBLE THE WOUND, BUT HE DARE NOT TURN HIS BACK ON MACHETE.

SHOW MY WHAT? TRUE FACE? AFTER ALL MY HARD WORK?

NOW, WHY WOULD I WANT TO DO SOME-THING LIKE THAT?

"I SHOW THE FACE I WANT TO SHOW, THE FACE PEOPLE WANT TO SEE AND BELIEVE. I TELL YOU ONLY WHAT I WANT YOU TO KNOW.

"LATER... MUCH LATER... NOT DAYS OR WEEKS... BUT MONTHS FROM NOW... WHEN IT IS ALL OVER..., AND I AM RICH, AND EVERYTHING YOU CARE ABOUT IS DE-STROYED...

"YOU WILL REALIZE I HAVE ALWAYS TOLD YOU THE TRUTH.

WORDS FAIL YOU, I TAKE IT.

LET'S SEE HOW THE OLD BUZZARD'S DOING.

I SAID "KEEP YOUR HANDS OFF HIM!"

BUT YOU SHOULD HAVE SAID, "HAND," NOT "HANDS." ONLY ONE, DO I HAVE TO KEEP RE-MINDING YOU OF THAT?

THE SHOUTS OF OUTRAGE BRING JOY TO MACHETE. HE FEELS BAD ABOUT THE OLD MAN, BUT HOW CAN HE HELP BUT SMILE UPON SUCH GLORIOUS FORTUNE. THIS IS GOING TO TURN INTO A SLAUGHT-ERING OF THE SOUL----AS BLOODY AND REPULSIVE AS RIPPED ENTRAILS. A SLAUGHTERING OF RESPECT--BUTCHERING ADMIRATION THE WAY ONE WOULD A SIDE OF BEEF.

LOOK, ZORRO, HAS STRUCK THE REGENCY ADMINISTRATOR TO THE GROUND!

AND HE HAS NO SWORD TO DEFEND HIMSELF. HAS THE FOX GONE MAD?

BARNABE CRESPI'S FINGERS CURL ABOUT THE HILT OF HIS SWORD, READY TO DRAW IT AGAINST ZORRO--

AN ACT HE WOULD NEVER HAVE BELIEVED HE WOULD DO.

EVERYTHING SEEMS SO NORMAL ABOUT THE DAY, EVEN GRIPPING THE REINS CONFIDENTLY, WHILE IN GALLOPING MOTION, THE STRONG, SATISFYING SMELL OF HORSE-SWEAT, THE SUNLIGHT GLISTENING ON DRYING BLOOD. "

HE IS GOING TO ATTACK ZORRO, AND BECAUSE EVERYTHING IS *NOT* NORMAL--

--EVERYTHING IS MADNESS AND MUTILATION--

--HE CANNOT GO WHERE HE WANTS TO GO-- WHERE HE WOULD GO IF THE WORLD WERE SANE.

TO DON ALEJANDRO, WHO MAY ALREADY BE DEAD, HE CAN'T BE SURE, HE CAN'T EVEN PAUSE TO CHECK--
--FOR HE MUST BE READY TO SLASH A MAN HE HAS ALWAYS THOUGHT OF WITH GREAT RESPECT.

BARNABE CRESPI HAS *TASTED DIRT* BEFORE; THERE IS NOT A VAQUERO IN SOUTHERN CALIFORNIA WHO HAS EARNED THE *TITLE*, WHO HASN'T TASTED OF THE LAND--

--HASN'T UPON SOME OCCASION HIT THE *EARTH SO HARD* IT HAS FORCED THE AIR OUT OF ONE'S LUNGS WITH A *VIOLENT WHOOSH!*

I'VE THROWN YOU AS *CLOSE* TO YOUR *MOUNT* AS I CAN, MAJORDOMO

GET UP ON HIM *FAST* BEFORE HE *SPOOKS* ENTIRELY AND RUNS AWAY. COME FOR YOUR *COMPADRES!*

HE USED TO TAKE *FALLS* MUCH *EASIER.*

ROLL WITH THEM. COME BACK UP ON HIS FEET MORE QUICKLY.

LUIS HOLDS THE SWORD BUT HE IS *CALCULATING* IN HIS HEAD HOW MANY *SECONDS* THEY HAVE BEFORE THE STAMPEDE REACHES THEM.

YOU ARE A *BRAVE* [AN]D *LOYAL MAN,* LUIS. YOU [D]ON'T HAVE TO DO ANY-[T]HING STUPID TO *PROVE IT!*

NOW, MOVE OUT OF THE WAY, PLEASE.

LUIS WOULD PROTEST, BUT THE ROAR OF HOOFBEATS IS DEVOURING THE WORLD--

I AM *GOING* FOR DON ALEJANDRO. I WILL NOT *LEAVE* HIM LYING THERE HELPLESSLY!

--AND IN THE *TERRIFYING CONFUSION,* THE ONLY CLARITY OF PURPOSE SEEMS LOCKED IN ZORRO'S EYES--

--AS IF, DESPITE THE VIOLENCE HE HAS SEEN THE FOX COMMIT--

--ZORRO ACTUALLY WILL *ATTEMPT* TO SAVE DON ALEJANDRO OR DIE IN THE ACT.

DON FRANCIS SANTIAGO HASTENS FOR HIS SON--

DON FRANCIS HAD FORCED RAMON TO COME, USING HIS POWER AS A FATHER TO COERCE RAMON TO ACCOMPANY HIM. WHEN HE COULD SEE, WHEN HE COULD PARTICIPATE, RAMON SO ENJOYED THE THRILLS OF THE MATANZA!

BUT WHAT COULD RAMON SEE TODAY? NOT HORSE OR COW OR CROW OR DEATH RUSHING AT HIM!
WHAT PURPOSE HAD HE HOPED TO ACHIEVE?
FORGIVE ME, LORD, HE PRAYS INTERNALLY, WITH PASSIONATE GUILT.

HIS SON WOULD DIE BECAUSE HE WANTED A MIRACLE, PRAYED THAT IF RAMON SMELT THE FAMILIAR ASSAULT OF BLOOD IN HIS NOSTRILS, HEARD THE SOUNDS OF VAQUEROS IN ACTION, THAT SOMEHOW IT WOULD DELIVER HIM FROM MELANCHOLY AND SELF-PITY.

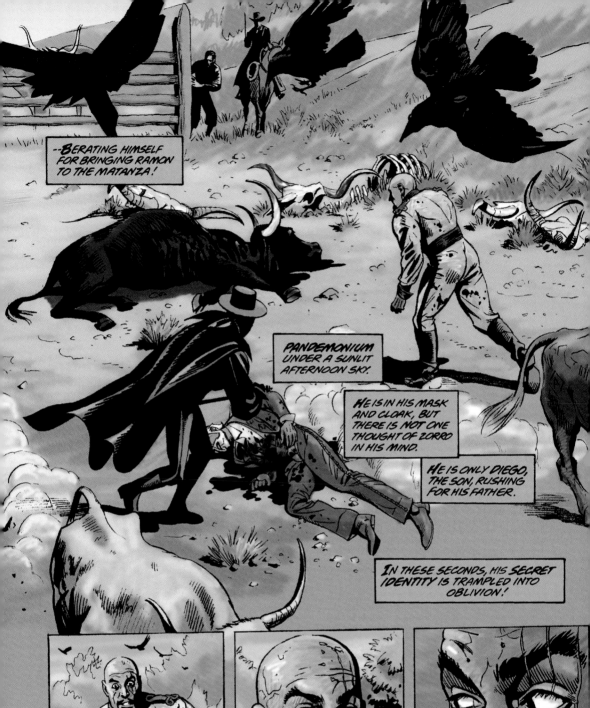

--BERATING HIMSELF FOR BRINGING RAMON TO THE *MATANZA!*

PANDEMONIUM UNDER A SUNLIT AFTERNOON SKY.

HE IS IN HIS MASK AND CLOAK, BUT THERE IS NOT ONE THOUGHT OF *ZORRO* IN HIS MIND.

HE IS ONLY *DIEGO*, THE SON, RUSHING FOR HIS FATHER.

IN THESE SECONDS, HIS *SECRET IDENTITY* IS TRAMPLED INTO *OBLIVION!*

LUCIEN MACHETE KNOWS HE ONLY HAS SECONDS TO MAKE A *DECISION*, IF THERE IS ANY DECISION *OTHER* THAN FLIGHT, ON WHAT HE CAN DO TO SAVE HIS LIFE.

ODD HOW THE DAY HAS GONE. VERY *EXHILIARATING!*

FROM THE *UNEXPECTED*, LIKE DON *ALEJANDRO* BECOMING HIS SACRIFICE, TO THE *FORTUITOUS ARRIVAL* OF ZORRO WHOM HE COULD INCRIMINATE, AND MAKE LOOK THE VILLAIN.

AND NOW, AFTER SUCH SWEET *INITIAL TRIUMPH*, HE MIGHT DIE BEFORE BEING ABLE TO *CAPITALIZE* ON SUCH GOOD FORTUNE.

HE HASN'T TIME TO CONSIDER IF THERE IS SOME LESSON TO BE LEARNED FROM SUCH SEE-SAW TURN OF EVENTS.

LUCIEN MACHETE IS *AWASH IN CONGEALING BLOOD.*

IN LESS THAN A MINUTE, IF HE DOES NOT ACT QUICKLY, NO ONE WILL BE ABLE TO *DISTINGUISH* THE DRYING BULL'S BLOOD FROM HIS OWN.

HIS EYES SEEK ESCAPE.

RAMON SANTIAGO IS FRIGHTENED. HE DOES NOT KNOW *WHICH* WAY TO MOVE.

IF HE RUNS, HE WILL SURELY TRIP AND FALL. HE NOTES THIS AS *FACT*, NOT SELF-PITY.

BUT DEATH IS *NEAR*, AND HE REALIZES, QUITE PROFOUNDLY, THAT IN *FEAR* THERE IS *MORE* LIFE THAN IN BITTER ANTIPATHY.

AND THAT, WITH THE AWARENESS OF DEATH SO CLOSE --

HE CAN'T OUTRUN THE CATTLE ON FOOT, EVEN ON HORSEBACK IT WOULD BE A *GAMBLE* HE WOULD NOT WANT TO HAVE TO *BET* ON.

NO ROCKS TO HIDE BEHIND. NO TREES TO OFFER A BARRIER.

EVERYONE FLEEING!

EXCEPT THE BULL CARCASS.

EVERYONE HOPING THEY CAN ESCAPE.

THE BULL!

THE DAMN BULL HE SLAUGHTERED MIGHT JUST SAVE HIM!

--THE *LOSS OF SIGHT* AND *UNSCARRED SKIN* AND *PHYSICAL PERFECTION* IS RENDERED *INSIGNIFICANT.*

BUT MOST WITH DEATH CLOSE ENOUGH THAT HE CAN FEEL IT UNDER HIS FEET IN THE SHUDDERING EARTH--

--HE SUDDENLY KNOWS HE WANTS TO *LIVE!*

THE FIRST THING SERGEANT DEMETRIO LOPEZ GARCIA IS AWARE OF IS THE SPLOTCHES OF BRIGHT RED IN THE TRAMPLED MUCK.

THE ROAR OF THE RECEDING HERD STILL PERVADES THE AIR, BUT THE SIGHT OF BLOOD, IS MORE COMPELLING.

HE STARES AT THE CRUMPLED BODY FOR LONG SECONDS.

THE STILL FINGERS, THE INERT TORSO, THE CRUSHED SKULL SPLINTERED UNDER CATTLE'S HOOVES--

--ALL ARE UNRELENTING TESTAMENT THAT GABRIEL CADIZ IS DEAD.

AND DEATH MAKES HIM FEEL SO INADEQUATE.

IF HIS PUDGY FINGERS HAD THE SKILL, HE WOULD MEND GABRIEL CADIZ, PIECE TO-GETHER THE BROKEN BONE.

BRING LIFE BACK INTO THE EYES.

AND HE PRAYS FOR THE MEN CAUGHT IN THE CATTLE'S BRUTAL ONSLAUGHT--

--PRAYS AGAINST MORE DEATHS.

REGRETS SLASH INTO HIS MIND. FOR SOME REASON THERE IS A VITAL IMPRESSION OF BEING SHACKLED WITHIN THE GUTTED WHALE.

DEATH WAS THE PREDOMINANT PRESENCE, THEN, ALSO, SO THAT NOW THAT DEATH THREATENS A LAST, DISTURBING RESOLUTION --

-- HE FINDS ALL THE REGRETS ABOUT HIS LIFE ASSAULT HIM ANEW.

ALL THE DECEPTIONS HE HAD TO PERPETRATE TO CONCEAL HIS IDENTITY AS ZORRO.

ALL THE CONFLICTS BETWEEN FATHER AND SON --

-- THE SCHISM WIDENING.

HE'D SURVIVED THE CORPSE-PRISON OF THE WHALE CARCASS --

-- BUT HE STILL HADN'T FOUND A WAY TO TELL HIS FATHER THE TRUTH --

-- AND ONCE AGAIN DEATH THREATENS TO STEAL ANY SENSE OF FINALITY --

-- ANY RESOLUTION

THAT'S IT, TORNADO! RUN AS FAST AS THE STORM YOU ARE NAMED AFTER MOVES!

DON FRANCIS SANTIAGO CATCHES THE RAPID MOVEMENT, AND AT FIRST IS NOT SURE WHAT HE IS SEEING.

AND THEN HE REALIZES IT IS THE REGENCY ADMINISTRATOR BURROWING INTO THE SOFT UNDERBELLY OF THE BULL.

AND AS QUICKLY COMPREHENDS THAT HE AND HIS SON HAVE ONE CHANCE FOR ESCAPE.

NO TIME TO BE SQUEAMISH, LUCIEN MACHETE TELLS HIMSELF. LITTLE BIT OF BLOOD DIDN'T BOTHER HIM!

HELL, A LOT OF SPILLED BLOOD DIDN'T BOTHER HIM ONE WAY OR THE OTHER. HE DIDN'T MUCH UNDERSTAND PEOPLE WHO WERE MOVED TO TEARS OR THREW UP THEIR GUTS OVER A LITTLE BLOOD AND GUTS.

ZORRO WISHES THE RIDE COULD BE SMOOTHER.

HE CRINGES AT EACH JOLT THAT JOSTLES HIS FATHER'S LIMP BODY.

HANG ON, FATHER!

DON'T...

PLEASE...

DON'T DIE!

THE CATTLE **PART** AROUND THE **CORPSE**. THEY VEER ABRUPTLY, AS IF SENSING DEATH.

DON FRANCIS **STUDIES** HIS **BIBLE** NIGHTLY, THOUGH HE SELDOM FINDS MUCH IN THE **PASSAGES** THAT HOLD CORRELATION WITH HIS OWN LIFE IN **LOWER CALIFORNIA**.

STILL, HE **DUTIFULLY** COMMITS TO MEMORY CERTAIN SCRIPTURES, AND THE STEERS SEPARATING BRINGS ONE PASSAGE TO MIND: **EXODUS 14:16**.

"BUT LIFT THOU UP THY ROD AND STRETCH THINE HAND OVER THE SEA, AND DIVIDE IT; AND THE CHILDREN OF ISRAEL SHALL GO ON DRY LAND THROUGH THE MIDST OF THE SEA."

BUT EVEN AS THE WORDS PASS THROUGH HIS HEAD, HE IS MOST AWARE OF HIS SON'S HAND.

STILL HOLDING HIS.

THE GRIP STILL FIRM.

AN INITIAL COMMITMENT TO LIFE!

BERNARDO SHOUTS WITH GLEE AS IF HE HAD A VOICE THAT COULD BE HEARD.

DIEGO *MADE* IT!

HE KNEW DIEGO'D MAKE IT.

THAT'S THE WAY HE WILL ALWAYS REMEMBER THIS MOMENT, THAT HE NEVER DOUBTED THE OUTCOME AT ALL.

NO, BERNARDO. I CAN'T LEAVE HIM WITH YOU.

FOR ONE, YOU'VE *NO HORSE* AND SECOND, EVEN THOUGH YOU ARE MUTE, THE QUESTIONS YOU'D BE ASKED ABOUT *HOW* YOU CAME TO HAVE HIS BODY WOULD BE CEASELESS, AND NOT JUST FOR A DAY OR TWO.

AND EVERYBODY WHO ASKED YOU, AND THAT WOULD BE EVERYBODY FROM THE PADRE TO THE VAQUEROS TO THE DONS, WOULD ASK *ME* THE *SAME* QUESTIONS.

I HAVE TO TRUST HIM TO GARCIA'S *CARE*, AND THEN COME BACK FOR YOU.

I'LL DROP YOU AT THE *HACIENDA*, THEN RIDE TO THE PUEBLO FOR THE DOCTOR.

WHAT?

SI, I'LL *PRAY* THE DOCTOR CAN *SAVE* HIM.

BUT I WON'T STAY INACTIVE AT HIS *BEDSIDE.*

I'LL *CONTINUE* MY PRAYERS WHEN I *RIDE BACK* HERE, TO THE SLAUGHTER CORRAL, AFTER EVERYONE HAS GONE.

WHY? BECAUSE I DON'T BELIEVE FOR A MOMENT THAT THAT BULL RAN BERSERK WITHOUT MACHETE'S *FINE, MISSING* HAND SOMEHOW RESPONSIBLE.

NO, BERNARDO. DON'T ASK ME *HOW* HE DID IT.

AND YOU'RE RIGHT TO LOOK *PESSIMISTIC,* I CERTAINLY CAN'T *PROVE* IT.

BUT THAT'S WHY I'M RIDING BACK OUT HERE, TO SEE IF I CAN LEARN THE HOW OF IT.

I'VE GOT TO GET HIM TO *GARCIA,* BERNARDO.

I'LL BE BACK.

SERGEANT GARCIA IS BREATHING LABORIOUSLY, EACH BREATH COMING OUT OF HIS LUNGS ALMOST AS A BURDENSOME SIGH.

RUNNING IS NOT A DEED HE DOES EASILY.

HE STOPS, NOT BECAUSE HE IS OUT OF BREATH, BUT BECAUSE HE GLIMPSES THE DARK SHAPE.

AND HE IS FILLED WITH APPREHENSION.

HE DOESN'T KNOW WHAT TO EXPECT.

WILL THE FOX ATTACK HIM THE WAY HE DID THE REGENCY ADMINISTRATOR?

AND YET ZORRO'S DEMEANOR SEEMS SO GENTLE NOW; THE EYES BEHIND THE MASK FILLED WITH GREAT EMPATHY.

SOMETIMES, IT SEEMS TO GARCIA, NOTHING MAKES SENSE IN THE WORLD.

PLACE YOUR SWORD BACK IN ITS SCABBARD, SERGEANT.

I NEED YOU TO TAKE DON ALEJANDRO, CAREFULLY... BACK TO HIS HOME.

THE GUEST DINING ROOM IS EMPTY SAVE FOR BERNARDO. AT THE SIGHT OF BERNARDO'S DESPONDENCY, DIEGO'S HEART RACES. HAS HIS FATHER DIED?

WHAT'S WRONG, BERNARDO?

HOW DO I KNOW SOMETHING'S WRONG? TAKE ONE LOOK AT YOUR FACE, AND THEN ASK ME THAT QUESTION.

MACHETE'S HERE! NOW?

WHAT'S THIS?

YOU'RE GOING TO FIGHT ME?

OH, REALLY? AND WHAT WOULD YOU HAVE ME DO, BERNARDO?

PLAY THE FOP FOR MACHETE?

I'M NOT THAT GOOD AN ACTOR.

NO, I'M NOT!

I THOUGHT I'D SIT WITH YOUR FATHER UNTIL YOU RETURNED.

GRACIOUS, REGENCY ADMINISTRATOR. IT WAS...

IF THERE IS ANYTHING I CAN DO TO HELP DON DIEGO, PLEASE DO NOT HESITATE TO CALL ON ME.

I CAME TO VALUE YOUR FATHER AS A FRIEND.

DIEGO! THERE YOU ARE?

KIND OF YOU.

DON'T BOTHER SPEAKING NOW, GO SEE YOUR FATHER. I'LL LET MYSELF OUT.

THE SITUATION IS INTOLERABLE. HE CAN'T EVEN REFUSE TO LET MACHETTE VISIT HIS FATHER'S BEDSIDE.

THE MAN MAY BE RESPONSIBLE FOR HIS FATHER'S INJURIES--

--BUT EVERYONE BELIEVES HE IS THE HERO WHO SAVED HIM.

AND WHY WOULD A MAN BANISH A MAN WHO SAVED HIS FATHER?

HOW CAN HE?

fin